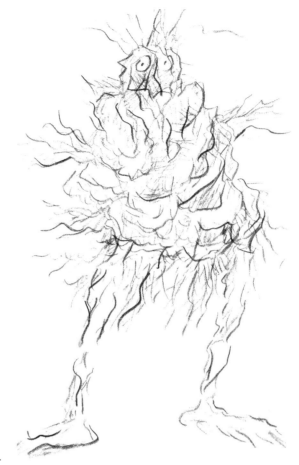

Edward Koren

The Capricious Line

by David Rosand

with contributions by Diana Fane and Edward Koren

Miriam and Ira D. Wallach Art Gallery

Columbia University in the City of New York

2010

This publication is issued in conjunction with the exhibition
Edward Koren: The Capricious Line, held at the Miriam and Ira D. Wallach Art Gallery,
Columbia University in the City of New York, 28 April through 12 June 2010.

The exhibition and publication have been made possible through an endowment
established by Miriam and Ira D. Wallach.

Many of the drawings in this exhibition were originally published in *The New Yorker*,
between 1965 and 2009, as noted in the catalogue section.

COVER: (front left to right) First Love II, I, III, 1982 (cat. 29, 28, 30);
(reverse) Birds and Earphones, 1988 (cat. 114)

TITLE PAGE: Comici IV, 1982 (cat. 34)

Published by the Miriam and Ira D. Wallach Art Gallery,
Columbia University in the City of New York

Distributed by the University of Washington Press, Seattle and London

ISBN 978-1-884919-26-8
Library of Congress Control Number 2010923543

Contents

Preface

The Miriam and Ira D. Wallach Art Gallery of Columbia University is especially pleased to present *Edward Koren: The Capricious Line*, for the exhibition is the occasion for the artist's return to the site of his early triumph as a graphic satirist, his alma mater. As a student in Columbia College, from which he graduated in 1957, Edward Koren made his mark as an artist for *Jester of Columbia*, the college's humor magazine, of which he was eventually editor in chief. It was in the pages of *Jester* that he discovered the creatures of his own invention that were to become his career-long companions, at once his creations and his muse. Koren published his first cartoon in *The New Yorker* in 1962, the first of more than one thousand to date; he is, of course, best known for his cartoons and covers for that magazine, as well as for his prize-winning illustrated books. Beyond his work for publication, however, Koren has been drawing as an end in itself. In what has been referred to as his "Fine Art or Uptown Stuff," the artist has been exploring the graphic potential of his own imagination. Many of these drawings are of surprisingly large size and have never before been exhibited publicly. Presenting the work of some five decades, this exhibition reveals that fuller range of his achievement. The imagination of an artist in continuing dialogue with his own inventions yields a gallery of fantastic creatures capable of a remarkable variety of expression. Koren's art is all about drawing and the incredible worlds it can open and record—and the sheer fun of it.

Following the lead of the artist, the exhibition moves between the poles of reality and fantasy, illuminating his sources of inspiration and social, cultural, and environmental concerns. One group of theatrically posturing figures, never before exhibited, offers Koren's variations on the characters of the *commedia dell'arte*, confirming his lineage from the *capriccio* of the seventeenth and eighteenth centuries. Another group making its first public appearance explores his fascination with the natural world and its inhabitants; inspired by dioramas at the American Museum of Natural History but generated more by the momentum of his own graphic impulse than by any laws of Darwinian evolution, these

critters introduce a new and majestic species in Koren's bestiary. His creatures seem to be in perpetual motion, a state the artist clearly shares with them. Koren is an avid bicyclist, and the exhibition includes a section devoted to very recent drawings that celebrate the union of bicycle and rider as dynamic form in space—however bumpy the road.

These ambitious drawings introduce the public to that lesser known side of Koren's art, the "Uptown Stuff." Inevitably and appropriately, however, much of the exhibition is devoted to Koren's drawings for cartoons, although the two categories feed off and into one another. Notably larger than their reproduction in *The New Yorker*, most of these drawings are exhibited here for the first time. The selection focuses on his position as concerned observer of man's awkward relation with nature and as bemused commentator on the arts in contemporary society. His antennae up, Koren is a gently acerbic critic of a cultural scene that seems to cry out for his graphic commentary.

The last major exhibition of the artist's work, *Edward Koren: Prints and Drawings 1959–1981*, was organized by Nancy H. Liddle at the University Art Gallery of SUNY Albany in 1982. The catalogue included an essay by Daniel Robbins (1932–1995), then the May I. C. Baker Professor of the Arts at Union College and a close friend of the artist. We found that essay so rich in critical appreciation and affection that, rather than trying to select excerpts for quotation in our own catalogue essays, we decided to reprint it in its entirety and make it available as a supplement to our publication.

It has been our great pleasure working with the artist in preparing this exhibition, our progress often being slowed by time for laughter. For David Rosand, having drawn for *Jester* under the editorship of Edward Koren, it has also been a particularly gratifying experience to review and relive a time when college humor was genuinely funny—or so, in nostalgic retrospect, it seemed to us. As curators, we are happy to help the artist send some of his more fantastic creatures out into the world, to meet new audiences and make new friends.

Joining us in this enterprise, an enthusiastic participant as much as efficient facilitator, was Sarah Elliston Weiner, the director of the Wallach Art Gallery, to whom we are most grateful for her encouragement and help, as we are to Jeanette Silverthorne, the assistant director of the gallery. Our thanks go to Lillian Vargas for her careful attention to the myriad administrative details of this project and to Larry Soucy for his technical guidance and companionship in the joys of installation. The catalogue was in the talented hands of Jerry Kelly, who responded to the demands of the project with patience and grace. In Koren's home in Vermont, where we had the pleasure of reviewing his work, we benefited from Curtis Koren's warm welcome and Ben Koren's assistance in compiling the final checklist.

Diana Fane and David Rosand
Curators of the exhibition

Koren capriccioso

DAVID ROSAND

T he art of Edward Koren gives us a world of fantasy based firmly in reality. The fantasy is most clearly manifest in the creatures of his imagination and in the graphic activity of their imagining, the reality in their social situations, their actions and interactions. That combination has enlivened the pages and covers of *The New Yorker* for decades. Readers of that magazine have come to recognize themselves and see their values satirized, sharply yet sympathetically, in Koren's drawings—perhaps most especially residents of Manhattan's Upper West Side. The reach of his pen, however, extends well beyond such parochial limits to incorporate the urban, the suburban, the ex-urban, and the countryside, to examine humanity and its problematic relationship with its natural environment. Indeed, Koren himself has become a most responsible citizen of Brookfield, Vermont, where he was once captain of its volunteer fire department and continues to serve as an active member.

Beyond *The New Yorker*, however, there extends the deeper and richer territory of Koren's imaginary world, in which, pen in hand, the artist explores and satisfies his own inventive instincts. In that realm of fantasy—which, of course, in turn enables the special humor of his cartoons—he discovers new fauna, new creatures; making new friends, he introduces them to one another, creating social occasions and spawning graphic progeny. Speaking of the conception of his cartoons for *The New Yorker*, Koren acknowledged, "It is mysterious and marvelous the way it comes into being, the way ideas evolve by happenstance, through a thoroughly semiconscious process of trial and error and chance."[1] That exploratory and aleatoric impulse plays an even greater role in the drawings he has done not for reproduction but for himself. Transcending the situational realities that are essential to a cartoon, these graphic imaginings develop a creative momentum of their own; they tend to come in series, an initial idea inspiring variations on itself, as the artist's pen feeds off its own inventions and its own creative markings.

In its internal motivation, its self-inspiration, Koren's art belongs to a venerable

tradition, that of the *capriccio*. This was defined in seventeenth-century Italy and France as an art that owes more to the imagination and fantasy of the artist than to the rules of art. Although its protean manifestations eluded any clear definition, this art was generally agreed to have been the product of "a disordering of the mind" *(un dérèglement d'esprit).*[2] The classic pictorial epitome of this genre is plate 43 of Goya's *Caprichos*, published in the final year of the eighteenth century. There the draftsman has fallen asleep on his drawing table; he is surrounded by menacing creatures of his own fantasy, bats and owls at once emerging from and converging on the imagining mind. The text inscribed on his table famously declares the imagining mechanics of this art: *El sueño de la razón produce monstruos* ("The dream of reason produces monsters").

Based on whim, on the unpredictable creative impulse of the artist, *capriccio* first referred to a certain kind of practice in music. The performative and the improvisational became essential aspects of its application in the visual arts: the demonstration of art itself and the celebration of its inventive possibilities. *Capricci di varie figure* advertised the title page of a suite of fifty small etchings by Jacques Callot that appeared in 1617, and this publication was followed by suites of *diversi* or *varii cappricii et nove inventioni* issued by Stefano della Bella. That tradition of graphic invention extended into the eighteenth century with Tiepolo's *scherzi di fantasia* and the *invenzioni capricciose* of Piranesi. Featuring improbable companions or impossible architectural settings, the fantasy worlds created by these artists opened a dialogue at once internal and external, an unspoken discourse or exchange that was left to the viewer to fill in, if not necessarily to resolve. As a functioning genre, the *capriccio* invites—indeed, demands—the active engagement of the viewer, who, almost involuntarily, supplies a scenario, imagines the sounds of these silent images and the implications of their gestures. It is up to the viewer to bring some sort of interpretive closure to the open work; the initial creative dialectic between the artist and his creation is succeeded by a dialogue between the image and the viewer. The promise of some kind of resolution, the answer to a pictorial riddle, may be sought, but it is precisely the difficulty in synthesizing or reconciling the disparate parts of a *capriccio* that constitutes a special pleasure of the genre. The capricious composition will not be reduced to a final formula of significance; it remains an open work.

Della Bella referred to his graphic inventions as *griffonnements. Griffoner,* which translates as to scrawl or scribble, to scratch, affirms the creative motions of the artist's etching needle. *Griffoner* is precisely the word one wants in describing the pen work of Edward Koren. His is not a long line, not a line of grace; rather, his line is constructed out of a kind of tentative, exploratory scratching, a feeling of the way toward a contour, a surface, the building of form out of individual strokes. Koren's creative process begins with a meeting between the artist and the creature he is bringing into being. The evolving creatures themselves tend to confront their creator directly, staring back at him—even when they are without eyes (cat. 13–16). In the particularly hairy creatures of 1979, the pen strokes a body into existence around an empty core that we may read as face or merely nose; the various shapes of untouched paper constitute physiognomic variety within the group. Koren had already considered the possibilities of such distinction in cartoons for *The New Yorker* (fig. 1). Noses, and beaks, assume a primary role in establishing personality

in many of his creatures, as do of course eyes—or their absence. The multiple strokes that give life to these fuzzy bodies record in effect the artist's continuing intimacy with them; the draftsman's hand is an integral part of the imagining mind. Populated by the creatures of his own fantasy, this art becomes an extended family for the artist (cat. 18), a situation confirmed by another capricious artist, Picasso: "We are not merely the executors of our work; we *live* our work."[3]

Captions count, and not only for *New Yorker* cartoons. In Koren's *capricci* the titling of an image seems a continuing part of the artist's creative involvement with his creations. The titles assigned to these hairy beings assembled on paper— *The Sordid Perils, Cast a Cold Eye, More Lives Than One* (cat. 12–14)—add a further dimension to their already troubling presence, a significance implied. Such titles suggest a resonance that further engages us, challenges us, as viewers, to imagine meaning.

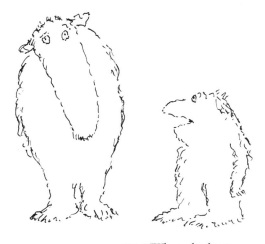

FIG 1 "Why such a long face?" *The New Yorker,* March 31, 1975.

Perhaps no Koren drawings relate as directly to earlier graphic masters of the *capriccio* as the group of colored-pencil figures that are clearly *comici dell'arte* (cat. 28–42). Here the swing of the draftsman's hand assumes a definite choreographic quality, inspired perhaps by the lighter touch of the pencil as compared to the pen. These figures emerge out of the rhythms of drawing, the constant motion of the marking implement, and they assume those rhythms as a part of their own personae. Presenting themselves with a certain corporal eloquence, they appear as on a stage, *commedia dell'arte* actors doing their shtick. Strutting and posturing, always in motion, whether dancing or bowing, they nonetheless remain conscious of and alert to the audience they are entertaining. Their first audience was, of course, their creator, whose imagining hand set them into motion. And when we, as viewers of the drawing, assume our seats, we are clearly invited to replay the creative scenario set before us. Retracing the energies and directions of the scribbled lines, we follow the corporal patter of these figures with our own bodies. Instinctively, we join the dance—as did their creator, who may have multiplied their legs for the performance. Once they turn their feet, to either left or right, they cease their bowing before us and begin their own lateral motion; with that realization of the narrative implications of their own graphic energies, the performance begins.

This group of drawings epitomizes a central aspect of Koren's graphic art: its total anatomical conviction. However scribbled or scratched, *griffonés*, however obviously the creations of the drawing act, the figures hang together; their motions conform to natural laws, respond to the balancing requirements of contrapposto. And when these comedians begin their patter, moving on or off stage with vaudevillian ostentation, we follow the pacing and rhythm of their progress with engaged pleasure. A similar conviction informs Koren's other, more fantastic creatures. The extension of a neck, a torso, or limbs is all that is needed to give a ball of fur with an open face a proper anthropic confidence of stance. Koren's line animates.

Although the *comici* are for the most part presented individually, they were apparently generated together, on large sheets of paper, and then subsequently separated. Some still share the paper with their fellow *personaggi*. Some of their hairy predecessors are in effect

catalogued on the page, specimens of an invented zoology, appearing in regular order as distinct units separated by red-pencil lines that grid the sheet (cat. 14, 17). The same red pencil, however, can effectively spatialize the setting, becoming a groundline upon which these creatures present themselves for viewing; and when to that red horizon is added an extension of blue, the lakeside scene of the Brookfield bathers is established (cat. 15–16).

Koren's instinct is to bring his creatures together, to set them on a common stage, a social space—as in *Just Typical* (cat. 43). The four-legged beasts of his zoological whimsy gather naturally in a museum-of-natural-history diorama, grazing in an accommodating landscape or perched high on a natural platform (cat. 49–52). Their direct confrontation of the artist/viewer suggests that our presence has somehow disturbed the social cohesion of the herd; again, titles confirm response (*Grazing Gaze*) or social bonding (*Seven Friends*). In these dioramas, creative fantasy begins with the great horned and antlered masks that stare out at the visitors to this imaginary museum; bodies are then added, literally extending these isolated visages into a shared space, which is then articulated as landscape. The creative sequence begins on the paper, with the distribution of the essential affective units, those faces with their linear protuberances curling out to decorate the surface, even as they articulate formal aspects of the supporting faces on which they weigh heavily. That flat gallery of masks is then transformed into a fully spatial setting, full-bodied beasts in a landscape. As he responds to his own graphic creations, Koren reaches beyond the surface and his pen opens a deeper world.

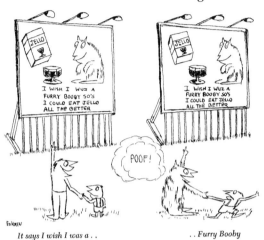

It says I wish I was a Furry Booby

FIG 2 From *Jester of Columbia*, spring 1954

Creating new realities, however fantastic, the capricious artist has always identified with his creations; giving life to them, he cannot help but participate in that life. In this, the artist is like the child who lives totally in the crayoned world of his imagination—at least so long as he is engaged in its creation. Again, Picasso bears master witness: "Of course, one never knows what's going to come out, but as soon as the drawing gets under way, a story or an idea is born, and that's it. Then the story grows, like theatre or life—and the drawing is turned into other drawings, a real novel. It's great fun, believe me. At least, I enjoy myself no end inventing these stories, and I spend hour after hour while I draw, observing my creatures and thinking about the mad things they're up to; basically, it's my way of writing fiction."[4]

Koren's furry creatures can be traced back to his undergraduate years when he imprinted his style on *Jester of Columbia*, the college's humor magazine. What may be the Ur-critter was then called a "furry booby" (fig. 2). But his population of beings has deeper and more complex roots, including the fact that Koren's father was a dentist. The artist still treasures an impressive display of Dr. French's "Five-Phase Anteriors" (fig. 3), inherited from his father, and those teeth evidently played an inspiring role in Koren's imagined worlds. Somehow he managed to animate these porcelain forms, softening and loosening them, endowing them with lives of their own (cat. 4–6). They lay out their own landscapes, spawn their own progeny. Paying homage to Dr. French, they find their shapes molded, ever so slightly, to suggest letters. Extracted cuspids and molars dominate these images, which can only be called dentalscapes; simultaneously menacing and protective, large teeth oversee

their smaller relations below. Diverse sizes and shapes operate to suggest spatial recession, with an implied horizon line confirming the terrain. Even as they suggest the space necessary for social interaction, these smaller dental units congregate to establish a sense of their own community; in that communal effort their bodies harden into building blocks, constructing urban landscapes of themselves.

The appeal of architecture is evident in Koren's work. His command of perspective in representing space—a quality that, among others, distinguishes his *New Yorker* drawings—is as instinctive as the anatomical confidence of his figural constructions. Architectural styles are part of his visual vocabulary, and he has made buildings the protagonists of his cartoons. Concern with their status and their fate inspires Koren the social critic to give them voice, and to animate the great historic monuments with his creatures (cat. 20–22). In his purer architectural fantasies he distributes buildings and monuments of varied cultural resonance over the sheet and then, as with his figural compositions, fills a landscape around them (cat. 25–27). Classical and medieval,

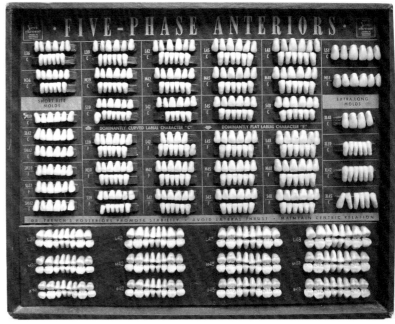

secular and sacred, pedestals and statues and architectural units are scattered across the page and the land: in the loneliness of their juxtaposition these *disjecta membra* recall the evocative poignancy of Piranesi's architectural *grotteschi,* the nostalgia of ruins. Here, too, Koren extends a tradition, bringing his own imaginings to revitalize the architectural fantasy as a genre.

If the built environment fascinates Koren, so do the tools and machines that build it. He designs machines of great ambition only to step back and appreciate the Rube Goldberg pretension of his own invention (cat. 67). "What is it like, working with your hands?" asks a woman in a *New Yorker* drawing (cat. 70). It is a question that Koren, like most artists, can answer for himself, sharing the satisfaction of the ex-urbanite transplanted to the country (cat. 72). He loves putting tools in the hands of his creatures: there is work to be done (cat. 73–75). To paraphrase the title of one of his books, simple living itself is hard work (fig. 4).

Koren's wit focuses on worlds he knows, but perhaps none has offered him such delicious opportunities as the cultural scene. A full participant in that scene, he has brought the choreographic talent of his pen to celebrate dance (cat. 116–120) and music, on all levels (cat. 110–115); sympathetic, however ironically, to the creative tribulations of the writer (cat. 107), he is an attentive listener at poetry readings (cat. 109). As an observer of the art world, he is a sharp-penned yet gently mocking critic of a scene that seems to demand his graphic commentary. From the stylistic winds of the sixties (cat. 93) and the graffiti art of the seventies[5] to the pretensions of collectors (cat. 98, 100) and the conduct of museum directors and museum visitors, as well as—inevitably—current critical

vocabulary (cat. 96–97), Koren has followed that world with amusement. After all, he is as much participant as observer. The artist himself has described his objective intimacy with the targets of his pen: "Clichés or ritual acts that annoy or amuse me or intrigue me are points of entry that allow me to construct small dramas, frozen in time and space, that people will laugh at (because they might have recognized themselves), and that *I* do laugh at (because I have recognized myself)."[6]

NOTES

1 "Speaking the Desperate Things: A Conversation with Edward Koren," interview by Judith Wechsler, *Art Journal* 43 (winter 1983), 381–85.

2 Antoine Furetière, *Dictionnaire universel* (The Hague, 1690).

3 *Picasso on Art: A Selection of Views*, ed. Dore Ashton (New York, 1972), 43.

4 Quoted by Roberto Otero, *Forever Picasso: An Intimate Look at His Last Years* (New York, 1974), 170.

5 Unfortunately, the drawing for the cartoon featuring a graffiti-covered bus (published in *The New Yorker*, January 20, 1973) was not available for this exhibition. It shows a clearly knowledgeable lecturer speaking to an appreciative group of art-lovers in front of a bus: "Note the densely distributed, yet perfectly balanced, relationship between the expressive line and the organic whole—how unity of surface is achieved by overtly lyrical variations of scale, texture, and color, giving three-dimensional form a spontaneous, plastically graphic definition."

6 "Speaking the Desperate Things," 381.

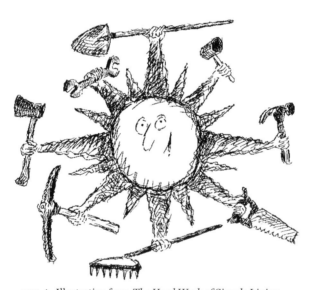

FIG 4 Illustration from *The Hard Work of Simple Living.*
New York: Chelsea Green Publishing, 1998

Edward Koren's Bestiary

DIANA FANE

Creatures abound in Edward Koren's drawings. Domestic or wild, realistic or fantastic, they appear in all shapes and sizes, interacting with humans or each other in a great variety of compositions and settings. Considered as a corpus, they are an unruly group, resisting classification in either art historical or natural history categories. Koren acknowledges that his "array of beasts and assorted animals [do not] constitute a cast of types or of characters that are constant and identifiable."[1] In fact, the creatures in many of his drawings seem to be in the process of evolving, not only through time, from one drawing to the next, but even on a single page. In *Hôtel Moderne* (cat. 8), for example, the central figures appear to have created their personae from a grab bag of human and animal traits and are now trying them out in a public plaza. In keeping with their location in front of a hotel, they are transients in form as well as space.

The beasts in Koren's cartoons tend to be physically more coherent but nonetheless each one remains sui generis. The gathering of wood sculptures illustrated here (fig. 5) gives a good idea of the variables Koren plays with to give each creature its distinctive character and mood: number of legs, stance, length of neck, placement of eyes and mouth, and teeth (or their absence). His pride in the singularity of his creations is apparent in his cartoon of a cheerful couple with hairy human bodies and oversized saurian heads, reclining on a hill in the countryside (cat. 47). "Isn't it astonishing," one says to the other, "that no two of us are exactly alike."

In his drawing of Noah's ark (cat. 45), a subject that artists throughout history have welcomed as an opportunity to portray the variety of the animal kingdom on a single canvas, Koren does not hesitate to insert a couple of his own creatures *and* their offspring— evidence of their having jumped the gun on procreation—in the line waiting to board the ark, suggesting that his species was included in God's original plan. What makes this furry family's intrusion into biblical history so funny is their very contemporary human

expressions of impatience and tension, apparent in the male's posture with his hand on his hip and the children's crossed arms, as they approach what appears to be an airport security gate manned by Noah.

In attributing human traits to animals, Koren joins a long artistic tradition that includes illustrated books of Aesop's fables, medieval bestiaries, J. J. Granville's lithographs, and, of course, the work of some of his fellow *New Yorker* cartoonists. We shouldn't discuss anthropomorphism in Koren's work, however, without acknowledging the presence of its opposite: theriomorphism. Koren's humans are frequently represented with animal traits. Among the attributes humans share with animals are graphically shaggy coats, although provided by Bloomingdale's rather than nature; an excess of hair; and prominent noses that more than hold their own in comparison to beaks and snouts. At first sight the scholars bustling around the Pantheon clasping books (cat. 21) appear to be human males (Koren can perhaps be forgiven for not including females in this Roman scene), but on close inspection we see they are the classic Koren creature stand-ins or "surrogates," to use his term, for distinguished men including himself (represented in the group portrait; see cat. 90). Does it matter which came first in Koren's worldview, man or beast? Of course not, and I think that he would not even be interested in considering the question. One of his goals in combining animal and human physiognomies with such wit and conviction is precisely to take man down a peg or two on the food chain. We are all in this together.

Koren, who has described his cartoons as "versions of proscenium theater,"[2] devotes a great deal of energy to delineating the physical settings in which his minidramas take place, whether a picturesque sunset unfolding before a young urban couple attempting to commune with nature (cat. 58) or a conventional Upper West Side living room with a Pandora's box of a beast lurking behind the couch (cat. 44). It is not surprising, therefore, that he has spent time studying the dioramas at the American Museum of Natural History, where the relation between the modeled and painted backdrops and the animals "on stage" is critical to our understanding of the groups' habits. As is evident from many of his cartoons (for example, cat. 66), Koren also values the hands-on craftsmanship and artistic skills required for the construction of these displays and is aware that they themselves are rapidly becoming a vanishing species. In a recent book, Stephen Quinn, an artist and naturalist who oversees the creation and conservation of the museum's dioramas, writes of their effect on the viewer: "All the details invite us closer. We are drawn to this place arrested in a moment, where wild and elusive creatures are encountered up close. Wilderness envelops us. Interrelationships between the earth and its creatures are revealed."[3] Koren's monumental drawings of the dioramas have captured that quality of verisimilitude that is both fascinating and disturbing (cat. 49–52). It is worth noting, however, that although Koren has spent considerable time at the museum and is obviously familiar with its dinosaur collections (cat. 48)—as is anyone who has raised children in New York City—the majestic antlered creatures in his drawings are more fanciful than factual. I checked.

In most of Koren's cartoons we are looking from the outside at the "drama" taking place with no knowledge of our presence. In the diorama drawings, the "actors" confront us and stare back with an intensity we cannot ignore. This is certainly what Koren intended as a call to action: nature's diversity must be documented and protected.

1 "Speaking the Desperate Things: A Conversation with Edward Koren," interview by Judith Wechsler, *Art Journal* 43 (winter 1983), 382.

2 Ibid.

3 Stephen Christopher Quinn, *Window on Nature: The Great Habitat Dioramas of the American Museum of Natural History* (New York: Abrams, 2006), 8.

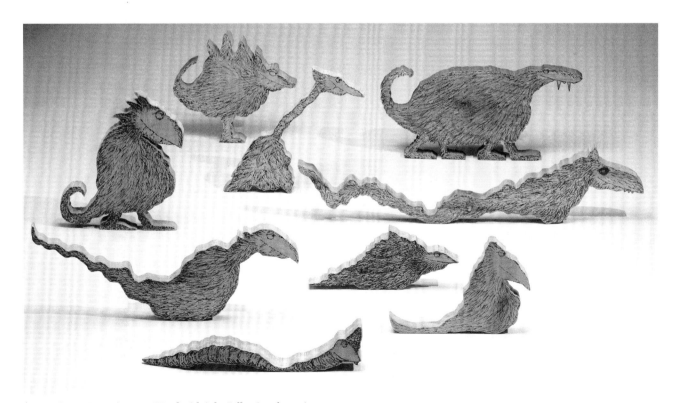

FIG 5 Group Portrait, 1981. Wood with ink. Collection the artist
Photograph: Richard Goodbody

Artist Notes

EDWARD KOREN

Having my work shown at Columbia is a special kind of homecoming. Columbia has been the rootstock of all I've done since graduating and moving on, and this exhibition is like bringing all my family and friends on paper back to show them where they came from—a trip to the old country for the next generation. The Wallach Art Gallery, where they have taken up residence, was previously the art history library—a space where I was introduced to the visual marvels and delights of the past. In a roundabout way, what I absorbed then—and since—is contained in one way or another in the works in residence on the Wallach's walls. My student days at Columbia were akin to the opening of an endlessly fruitful and exciting treasure chest—and my predilection to perceive visually, as well as verbally, was given much richness and embellishment by what I was discovering in the present exhibition space.

The other crucial room for me, in John Jay Hall, was home to the *Jester* office, the college humor magazine. I submitted some cartoons to the magazine soon into my freshman year and was jubilant to have them accepted—and to see them on pages that would be seen by scores of people. It was an immense thrill then, and a delight that has never entirely diminished. I contributed to the magazine during all my undergraduate years, learning more and more about drawing as I persevered. *Jester* was akin to an informal laboratory course, where I could put some of my newly acquired passions to use—where the study of Northern Renaissance painting could slip into a drawing of an architectural confection, or some reference to a humanities reading could be snuck into a caption. Drawing cartoons was where I could combine, on paper, all that my undergraduate mind was sucking up, and gleefully, carelessly put to a curiously unique use—and one that was, miraculously, appreciated around the campus.

One thing more Columbia bestowed on me during those years was a love of words and the keenness to hear them in all their nuance, and richness. I learned to couple this love

with what I was seeing, and used that in my early *Jester* work. It was a kind of internship for what was to become a lifelong passion and commitment. I am frequently asked which comes first in forming an idea for a cartoon, the words or the image. Peter Arno answered it for us all: "Unlike the chicken and the egg, there's only one answer: the idea comes first." In response to this eternal question, Arno said, "The last thing they do is just come [to me]. My ideas are produced with blood, sweat and brain-wracked toil." Charles Addams also spoke for his colleagues: "Doodling is one method of getting ideas. You sit there with a blank piece of paper and make doodles and one thing relates to each other in a strange sort of way and then you get the idea." My days at Columbia should be added as the reason my ideas are at all worthwhile, and take the shape they do.

My friend Calvin Trillin once referred to my somewhat unknown non-cartoon work as my "Fine Art or Uptown Stuff," this at a time when the majority of New York galleries were clustered around 57th Street and farther uptown. In the introduction to an early collection of my cartoons, *Do You Want To Talk About It?* published in 1976, he took up the question of how my published work differed from my other work by saying that "the magazine drawings often leave some doubt as to which animal [he had in mind] while the uptown stuff makes it difficult to tell whether what he had in mind was, in fact, an animal."

What I had in mind is this: I always thought that my comic work was fundamentally serious, and what might be called "serious work" had its basis in my generally comic disposition. The "Uptown Stuff," however, reflects my interests in a wide range of subjects not confined to cartoons, a format that requires tightly defined storytelling—a lightning-fast one-act play that takes place in a frozen moment in time, with a specific goal: laughter.

The "Uptown Stuff" is less constrained by time and space and more freewheeling. It is more my mind following the pen rather than the pen trailing my mind. The subjects are more or less the same, following all the interests, curiosities, obsessions, passions, and other stray thoughts that tend to invade my brain at all hours. Saul Steinberg once said that "drawing is a way of reasoning on paper." I would add meandering around the woods of reason, not quite knowing when you start out where you are going to end up. My kinship with the great Steinberg has been present in my mind ever since I started drawing; his mentorship and his achievements have always been an inspiration and model. Harold Rosenberg described him as "a writer of pictures, an architect of speech and sounds, a draughtsman of philosophical reflections." He was an artist whose path I wanted to follow.

In my cartoon drawings, I like getting things right. In drawings of stuff—objects, machines, structures, garb, all the things of the physical world—I try to get the details as correct as I can without dealing a death blow to a lively hand and dashing pen. I've taken as example the great *New Yorker* artist George Price, and his accurate as well as stylistically expressive and goofy rendering of loony objects, chaotic interiors, and architectural oddities. Of a wonderfully comic drawing of a plumber working in a flooded basement, Price maintained that no working plumber would find any problem with the fittings. (As both an engineer and, later, a dentist, my father prided himself on his craftsmanship and attention to detail, and appreciated how the physical world was constructed and held together. These admirations he passed on to me.)

What captures my attention is all the human theater around me. I can never quite

believe my luck in stumbling upon riveting minidramas taking place within earshot (and eyeshot), a comedy of manners that seems inexhaustible. And to be always undercover makes my practice of deep noticing even more delicious. I can take in all the details as long as I appear inattentive—false moustache and dark glasses in place. All kinds of wonderful moments of comedy happen right under my nose. My low expectations are never disappointed, or, as Lily Tomlin has observed, "No matter how cynical I get, I can never keep up."

Self-Portrait, 1991 (cat. 91)

Plates

PROOF – SHE PLAYED WELL, I SAY, THINKING OF YOU

Koren 64

She Played Well, I Say, Thinking of You, 1964 (cat. 1)

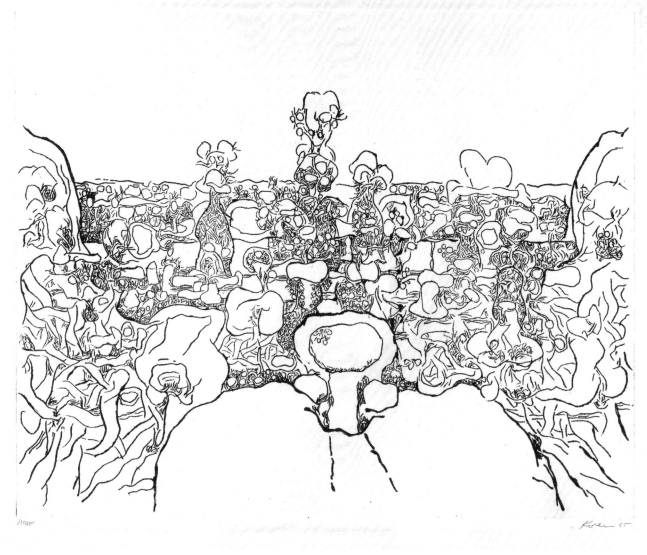

Through My Windshield, 1965 (cat. 2)

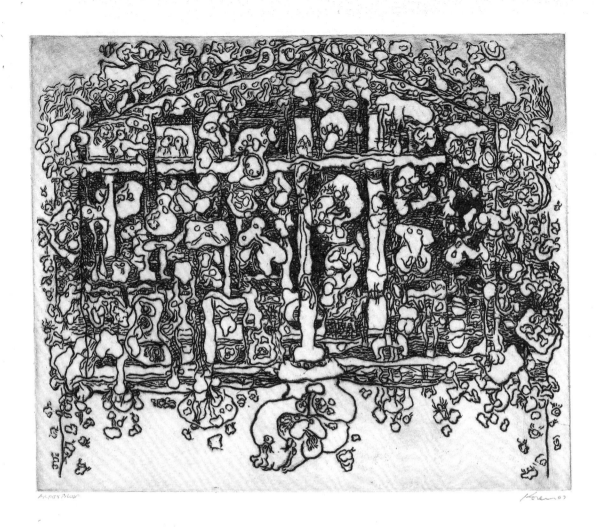

Historic Landmark, 1967 (cat. 3)

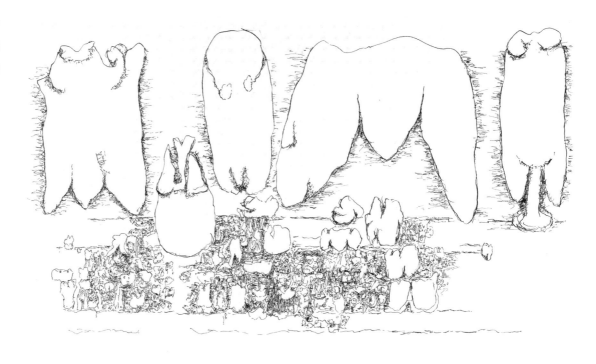

Shall We Dance? 1968 (cat. 4)

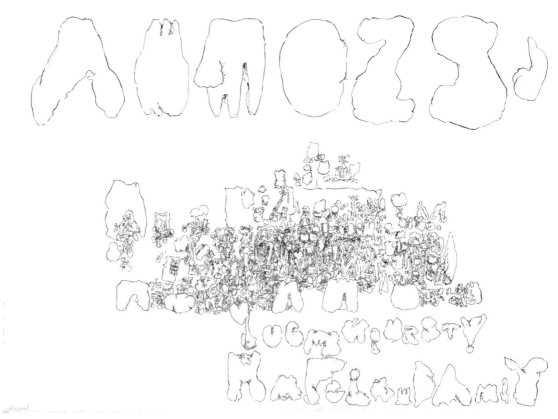

Homage to Dr. French, 1969–70 (cat. 5)

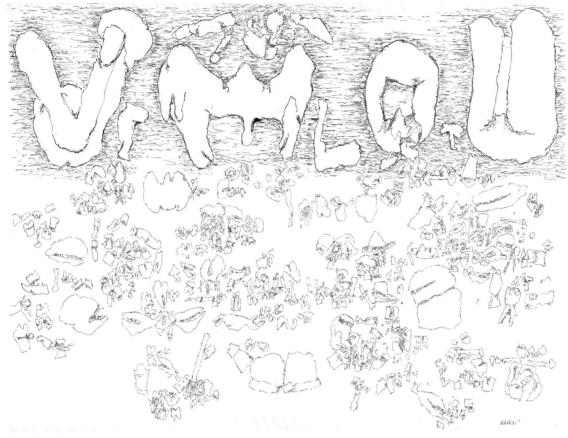

Too Many Teeth, 1970 (cat. 6)

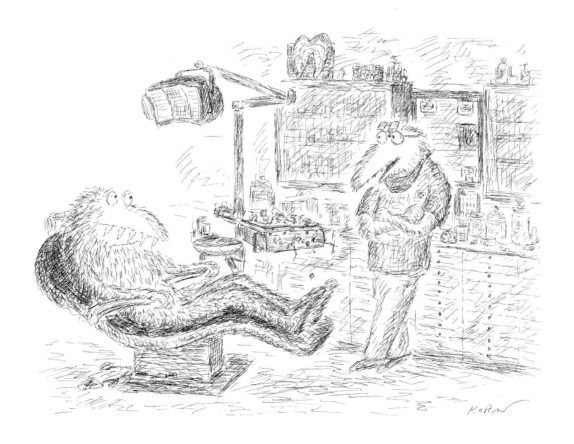

"I detect a little laxity in your flossing." 1991 (cat. 7)

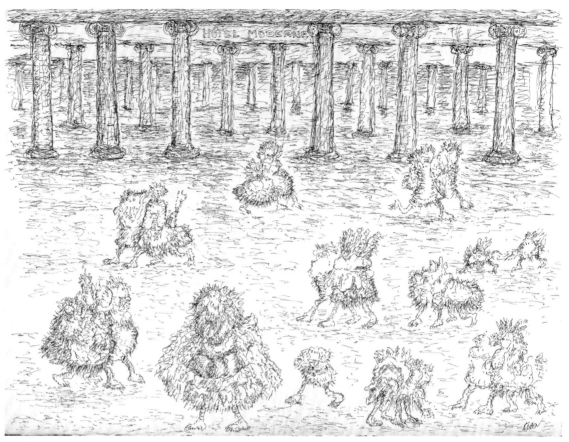

Hôtel Moderne, 1974 (cat. 8)

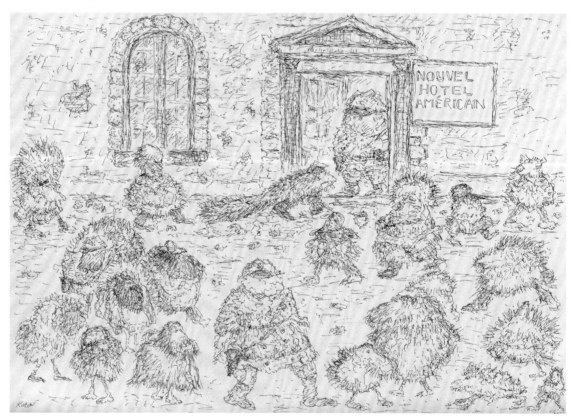

Nouvel Hôtel Américan, 1974 (cat. 9)

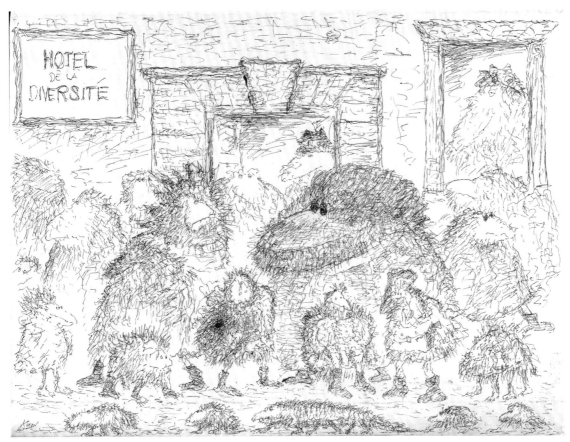

Hôtel de la Diversité, 1974 (cat. 10)

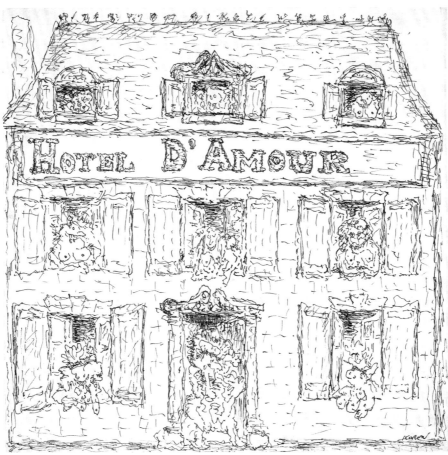

Hôtel d'Amour, 1974 (cat. 11)

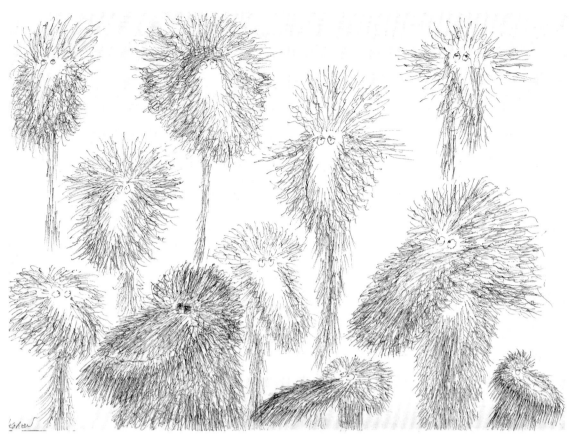

The Sordid Perils, 1979 (cat. 12)

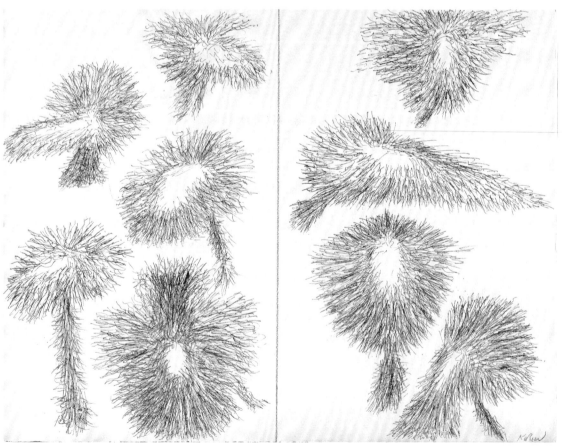

Cast a Cold Eye, 1979 (cat. 13)

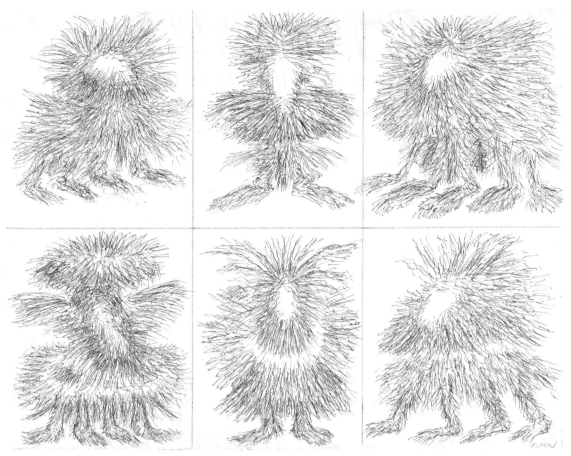

More Lives Than One. 1979 (cat. 14)

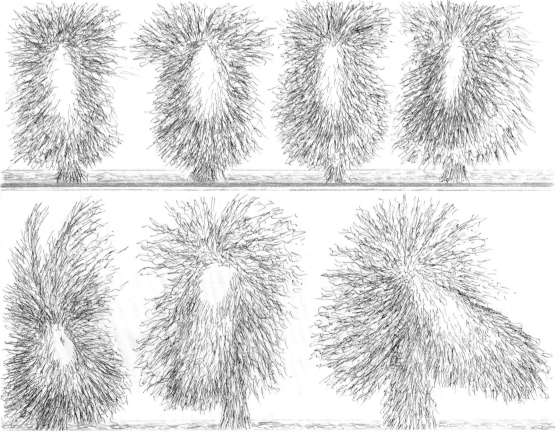

Brookfield Bathers I, 1979 (cat. 15)

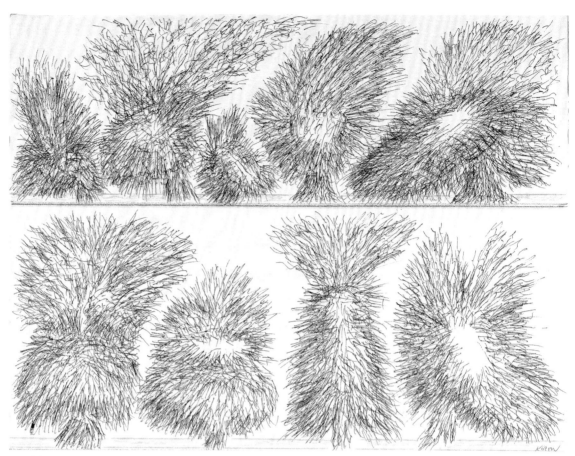

Brookfield Bathers II, 1979 (cat. 16)

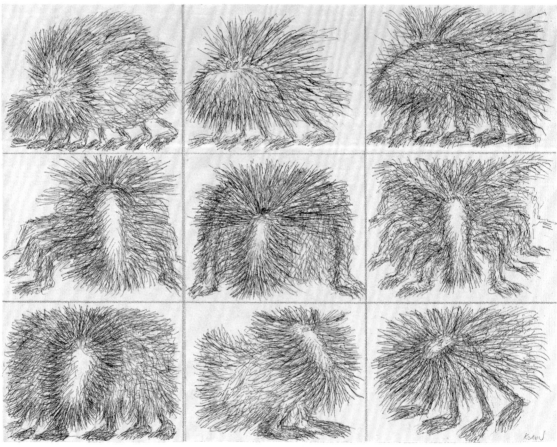

Brookfield Bathers IV, 1979 (cat. 17)

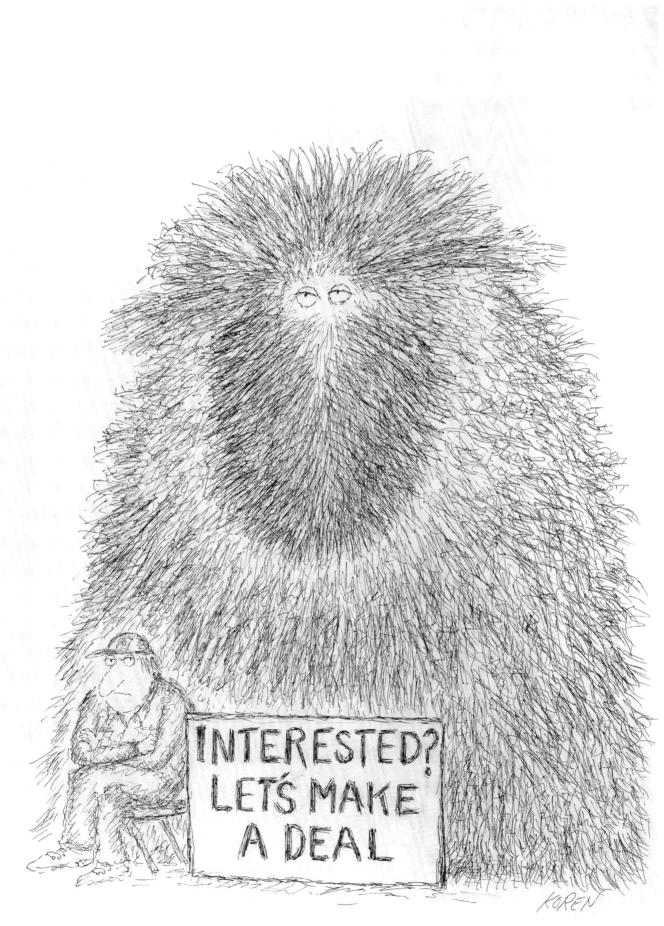

Interested? Let's make a deal. 1971 (cat. 18)

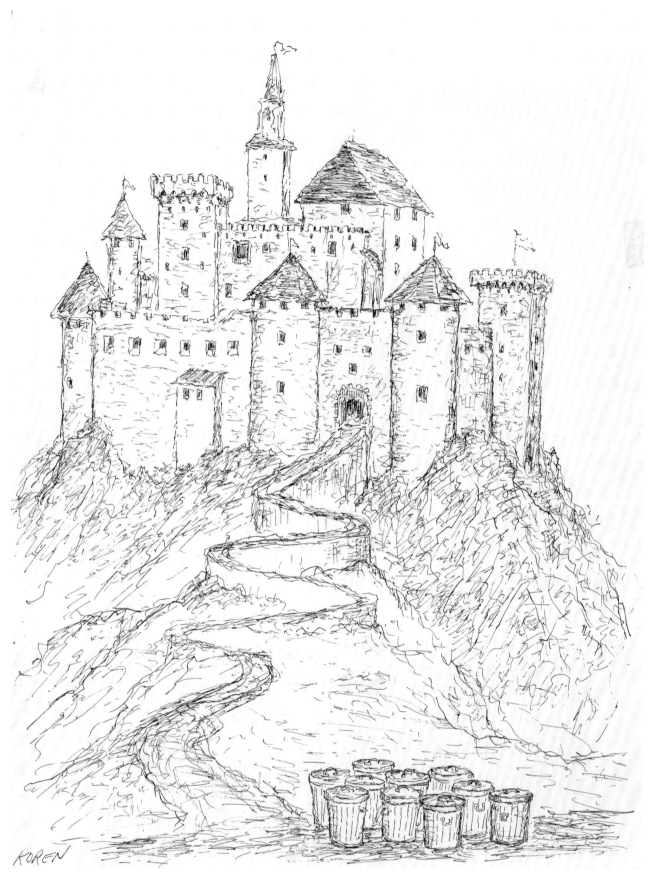

KOREN

Castle with Garbage Cans, 1971 (cat. 19)

"What did they give you – National Landmark or Historical Monument?" 1971 (cat. 20)

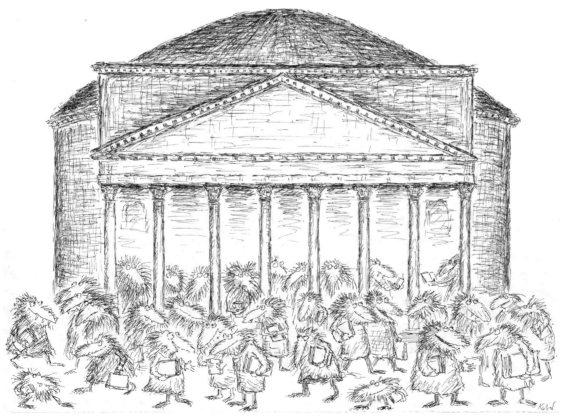

Pantheon Books: Cover of 1981 Spring Catalogue, 1981 (cat. 21)

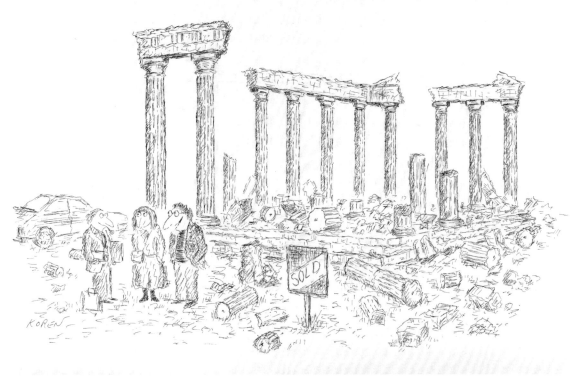

"Our goal is to modernize it but retain the historical flavor." 1987 (cat. 22)

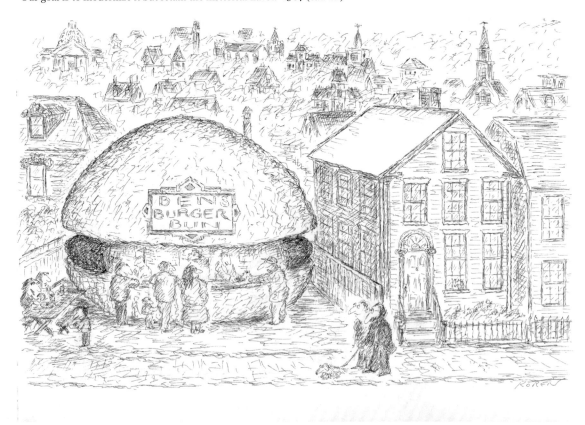

"And this one is listed in the National Register of Historic Places." 1990 (cat. 23)

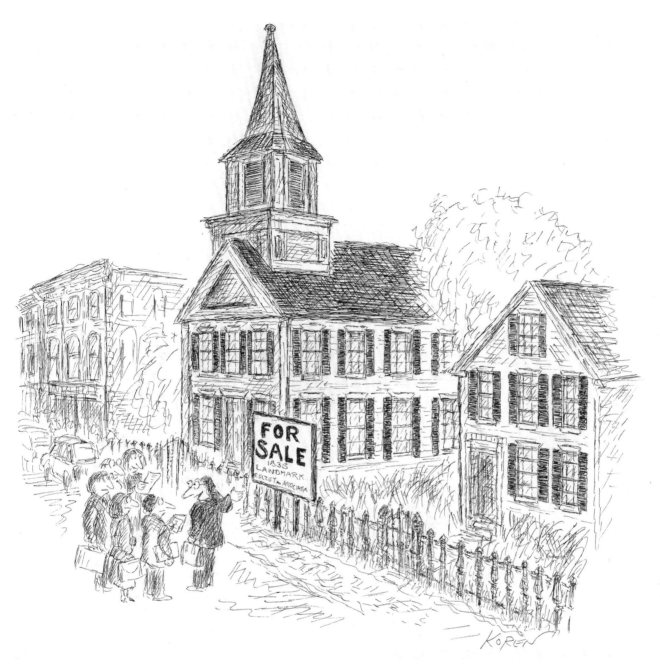

"Great for worship then! Great for retail now!" 1999 (cat. 24)

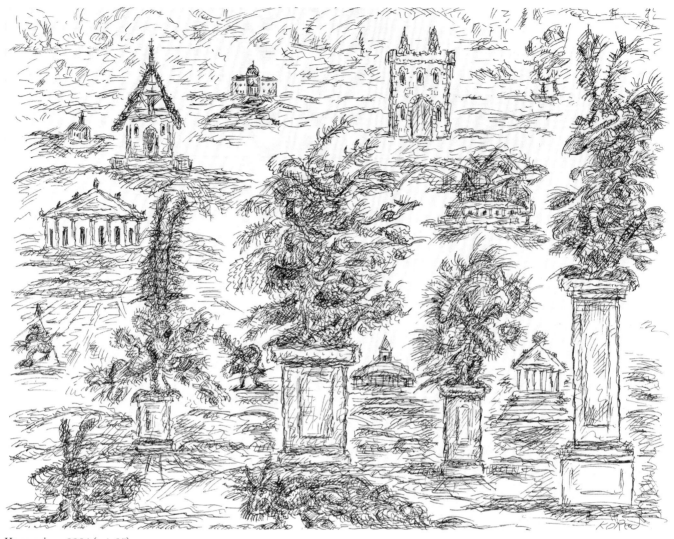

Honorarium, 2004 (cat. 25)

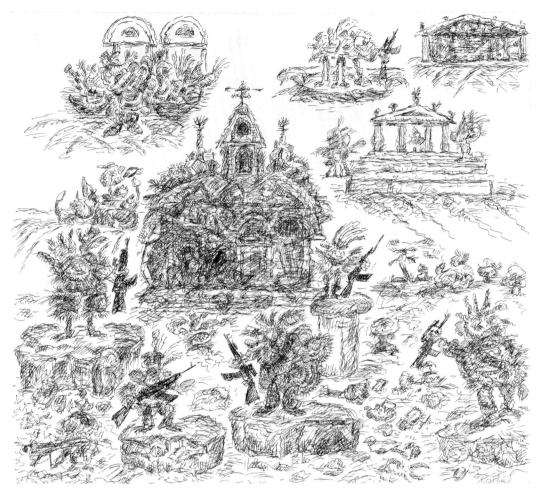

The Favors of Fortune, 2004 (cat. 26)

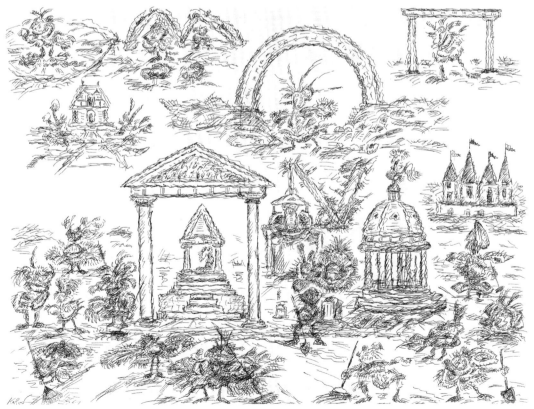

Nothing Is Lost, 2004 (cat. 27)

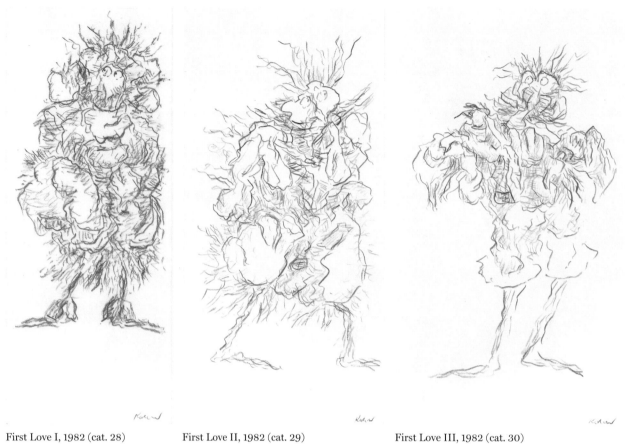

First Love I, 1982 (cat. 28) First Love II, 1982 (cat. 29) First Love III, 1982 (cat. 30)

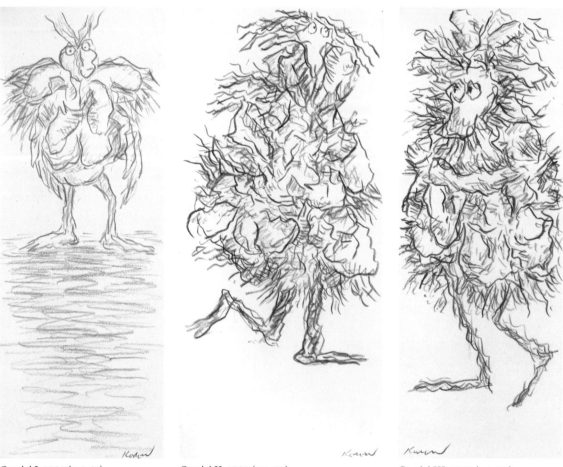

Comici I, 1982 (cat. 31) Comici II, 1982 (cat. 32) Comici III, 1982 (cat. 33)

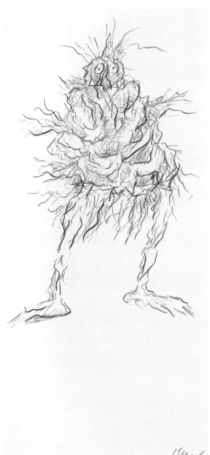

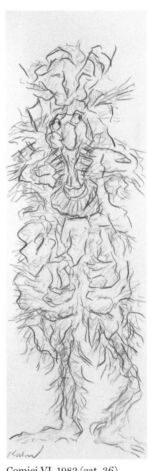

Comici IV, 1982 (cat. 34)

Comici V, 1982 (cat. 35)

Comici VI, 1982 (cat. 36)

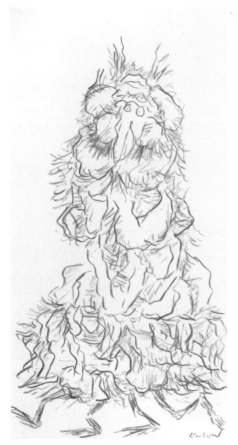

Comici VII, 1982 (cat. 37)

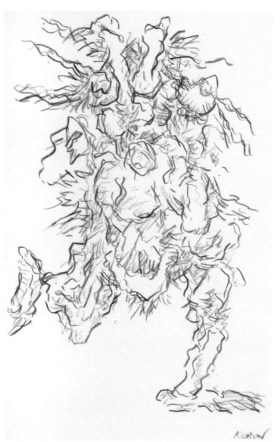

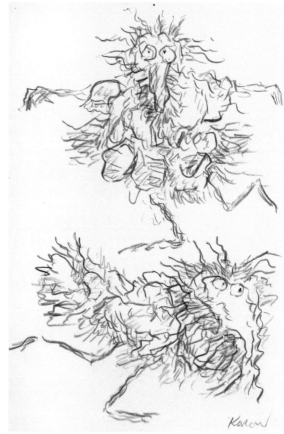

Comici VIII, 1982 (cat. 38)

Comici IX, 1982 (cat. 39)

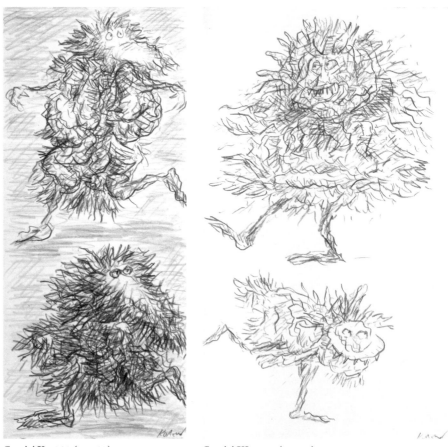

Comici X, 1982 (cat. 40)

Comici XI, 1982 (cat. 41)

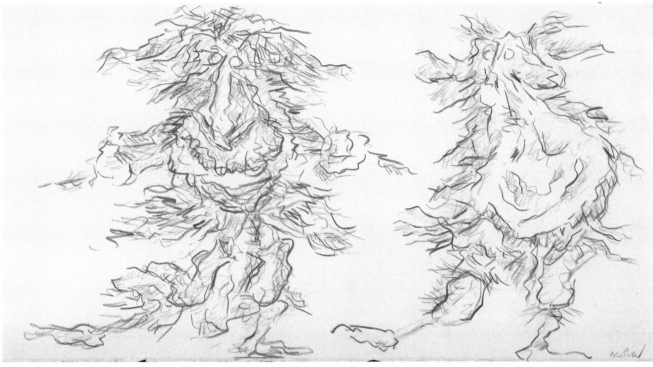

Comici XII, 1983 (cat. 42)

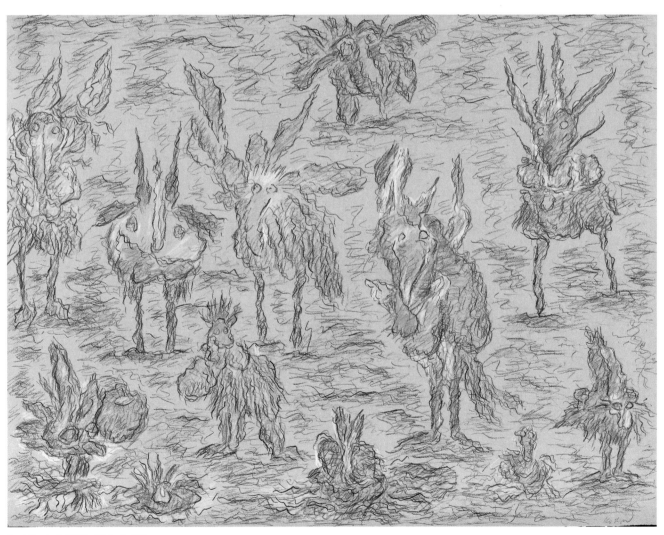

Just Typical, 1989–90 (cat. 43)

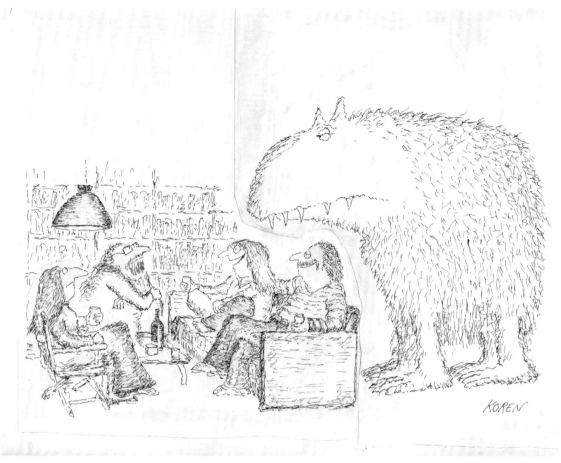

"We deal with it by talking about it." 1975 (cat. 44)

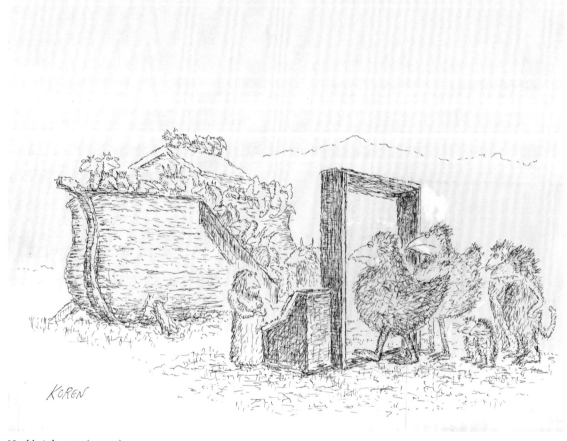

Noah's Ark, 1975 (cat. 45)

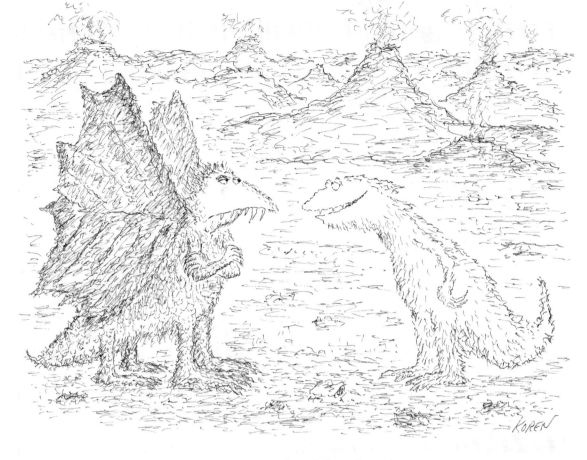

"The reason you all are becoming extinct is that you can't take a joke." 1977 (cat. 46)

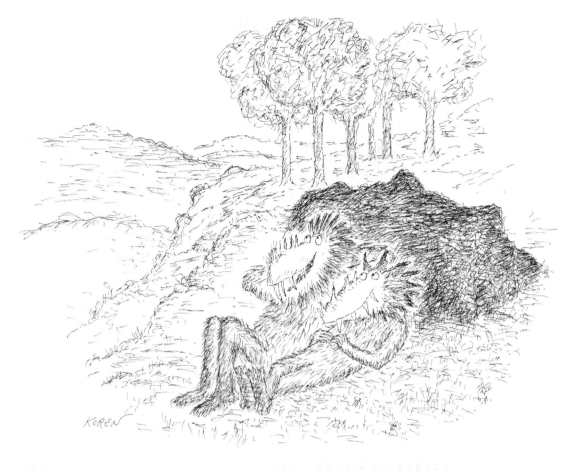

"Isn't it astonishing that no two of us are exactly alike?" 1982 (cat. 47)

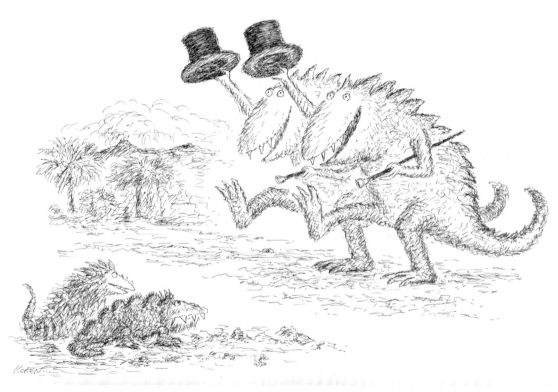

"It looks like the ornithosuchians are attempting a comeback." 1984 (cat. 48)

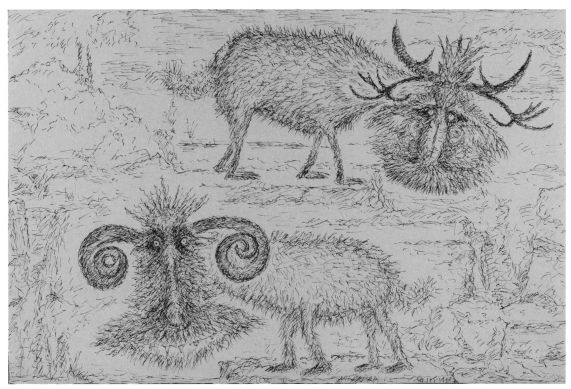

Grazing Gaze, 1985 (cat. 49)

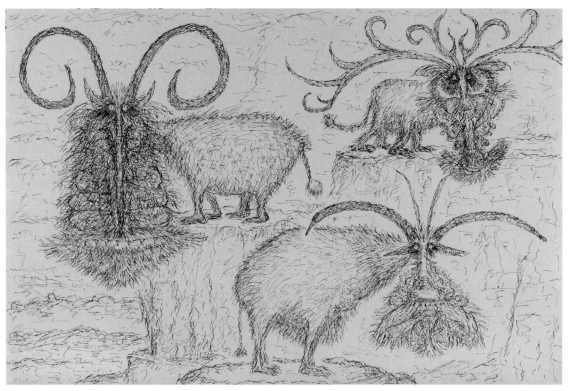

Blood Sound (after Paul Zweig), 1985 (cat. 50)

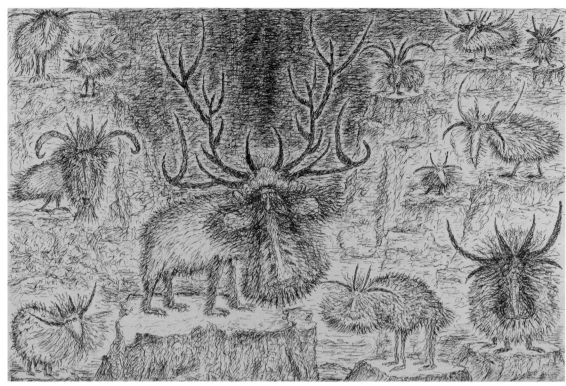

Sleepless Nights (after Paul Zweig), 1985–86 (cat. 51)

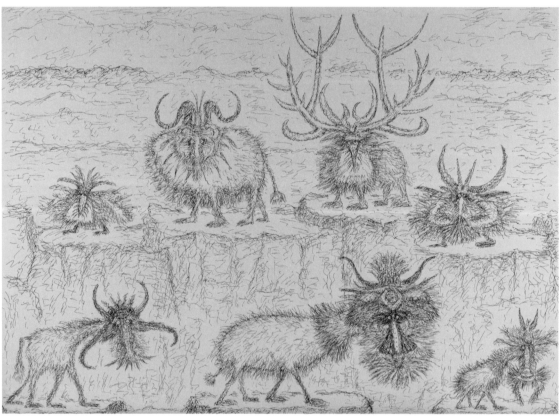

Seven Friends, 1987 (cat. 52)

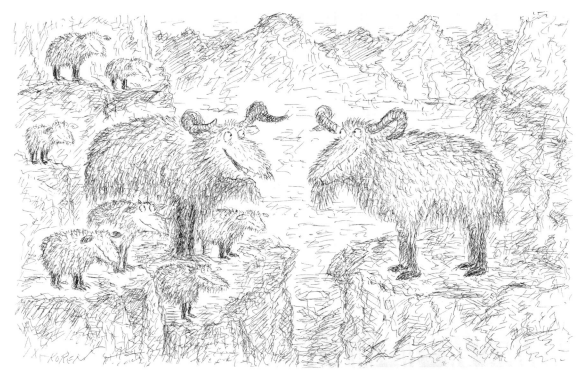

"This is a great place to raise children." 1990 (cat. 53)

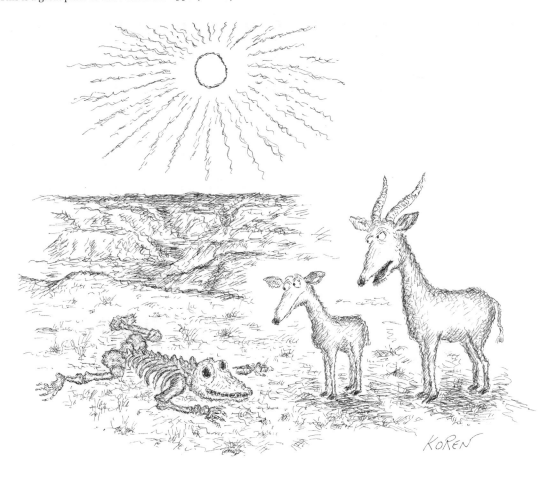

"The message here is 'Hydrate, hydrate, hydrate!'" 2007 (cat. 54)

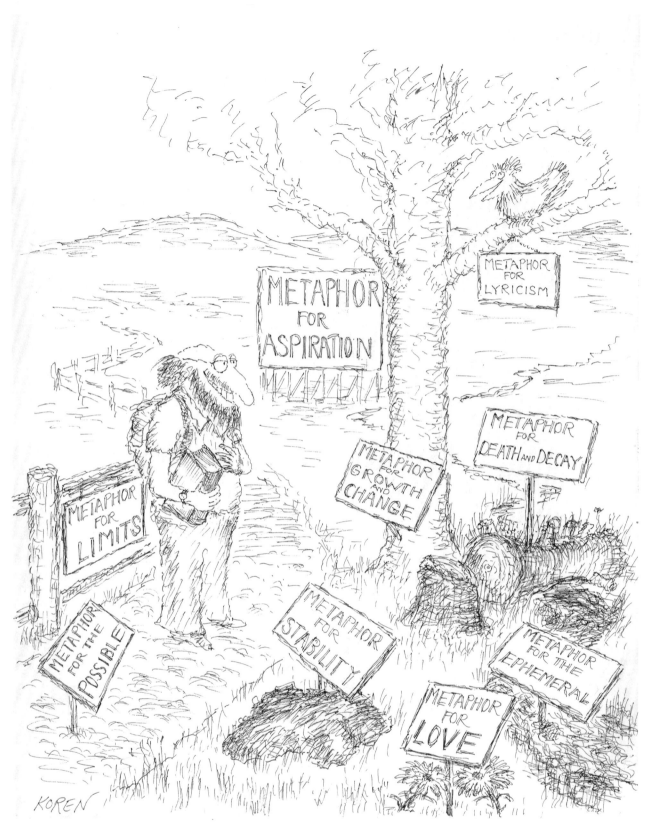

Landscape of Metaphors, 1979 (cat. 55)

50

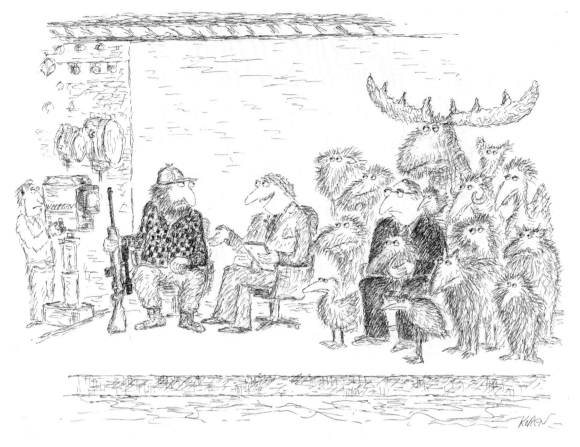

"And on my right is Joe Nast, representing an opposing viewpoint." 1982 (cat. 56)

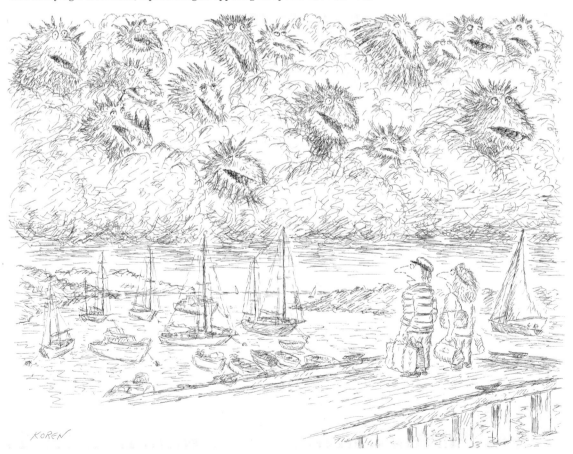

"The weather looks a little iffy." 1986 (cat. 57)

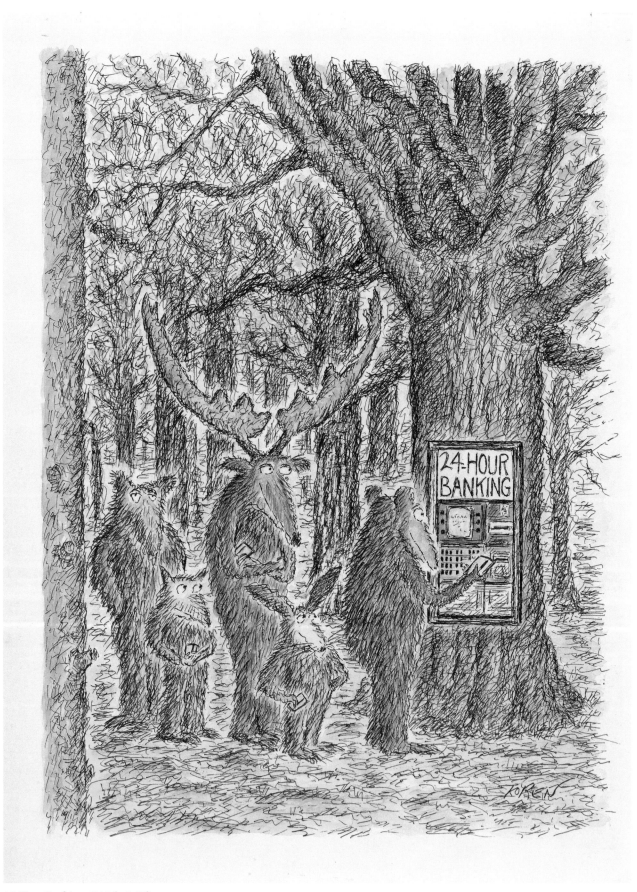

24-Hour Banking, 1990 (cat. 59)

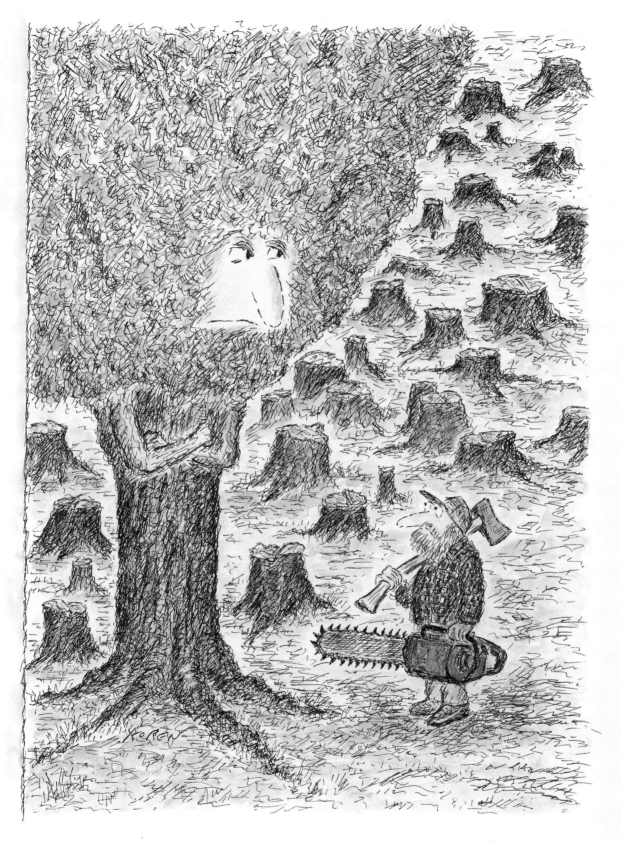

The Most Unkindest Cut, 1991 (cat. 61)

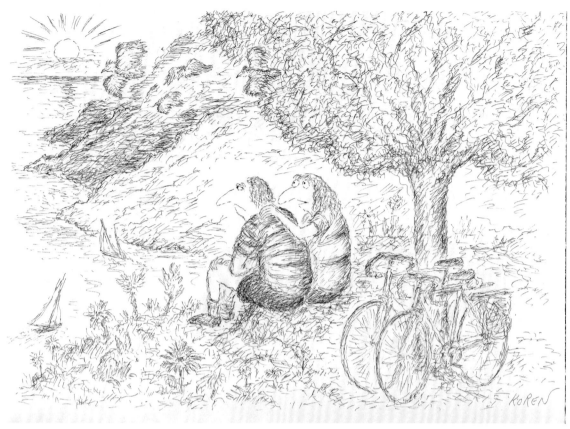

"Honey, are you thinking about the office?" 1989 (cat. 58)

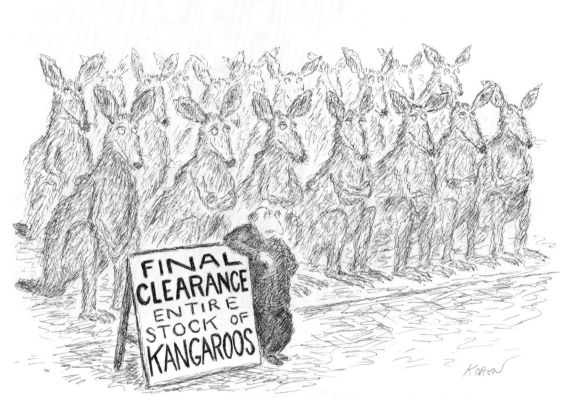

Final Clearance Entire Stock of Kangaroos, 1991 (cat. 60)

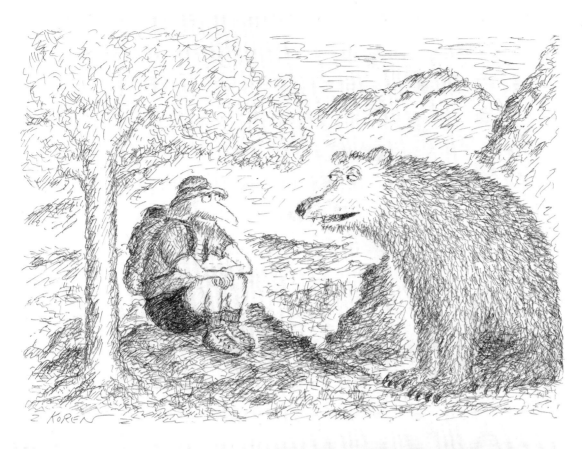

"You hate to shop – I hate to hunt." 1992 (cat. 62)

"Your father and I want to explain why we've decided to live apart." 1995 (cat. 63)

"I've been a great admirer of your work for years. It's a real pleasure to meet you." "I'm happy to meet _you_. I'm your biggest fan." 1983 (cat. 66)

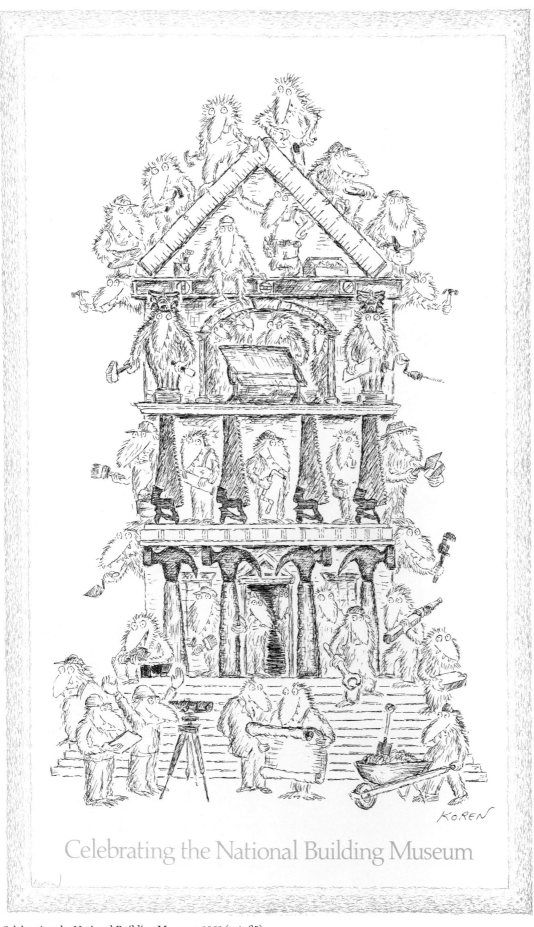

Celebrating the National Building Museum, 1981 (cat. 65)

"Your work must be very satisfying." 1969 (cat. 64)

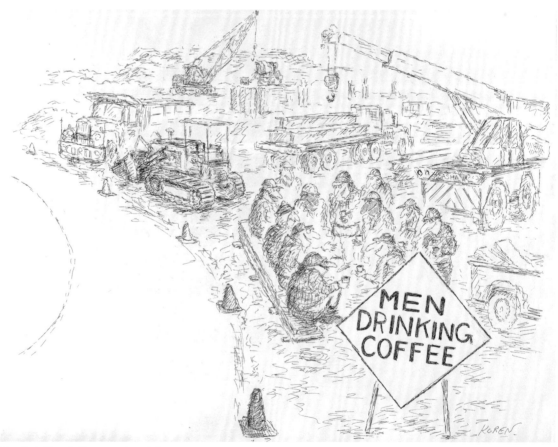

Men Drinking Coffee, 1984 (cat. 68)

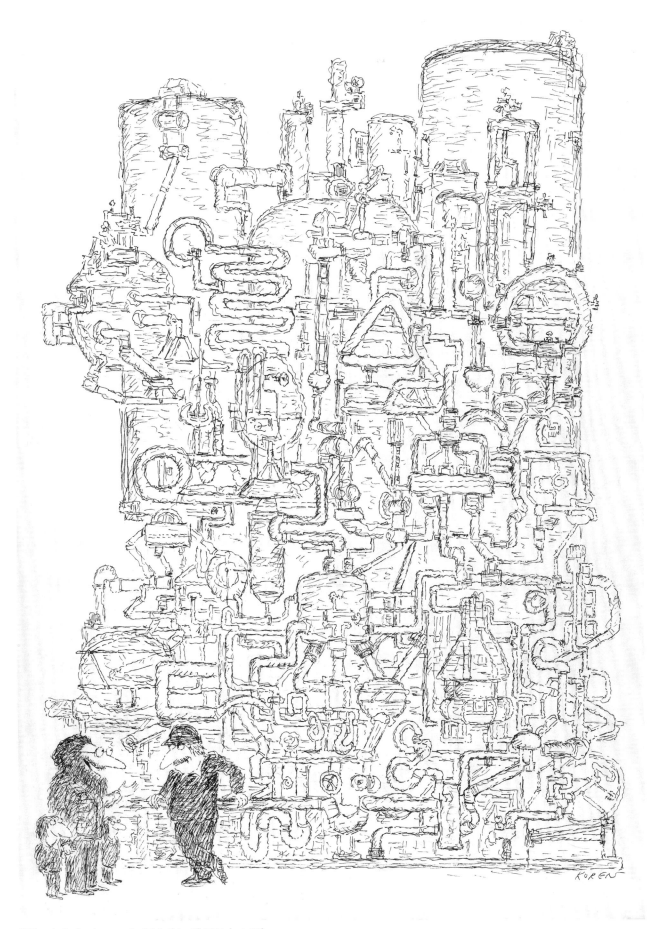

"Where's the business end of this thing?" 1983 (cat. 67)

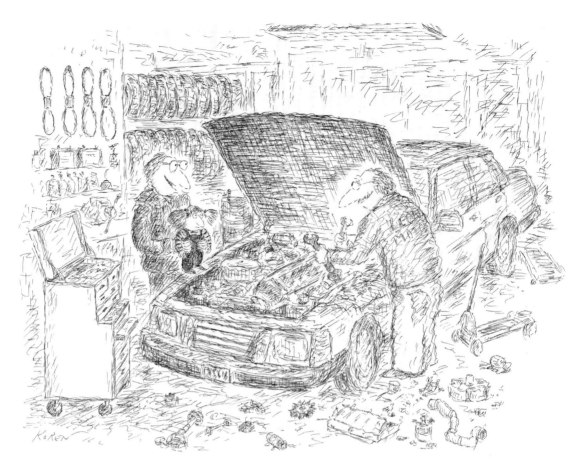

"I'd like my daughter to know something about engines." 1989 (cat. 69)

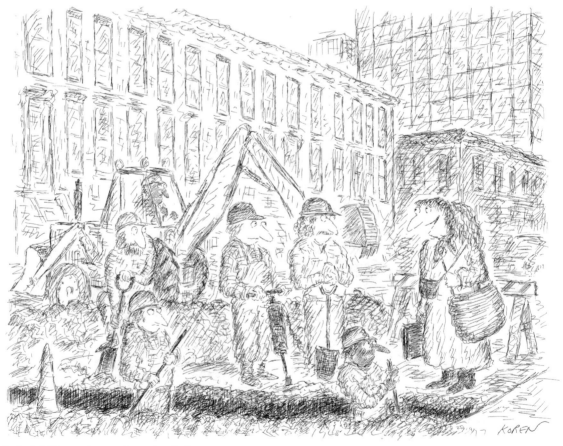

"What's it like, working with your hands?" 1990 (cat. 70)

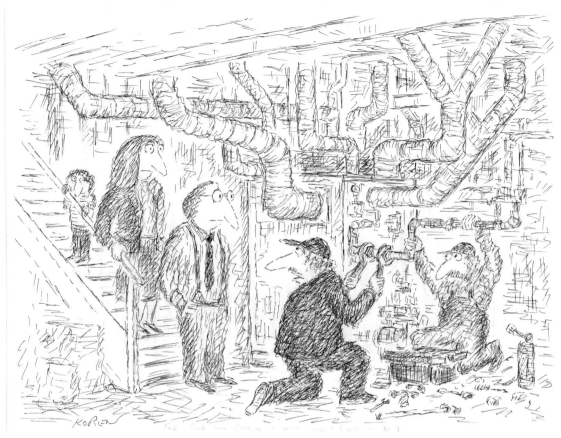

"We can't tell if it's a malfunction or a dysfunction." 1991 (cat. 71)

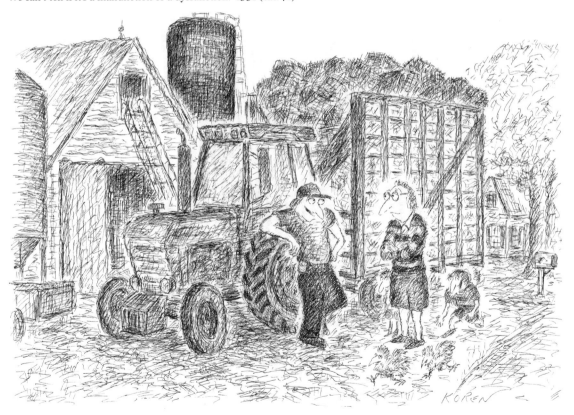

"I've done my tour of duty on Wall Street." 1992 (cat. 72)

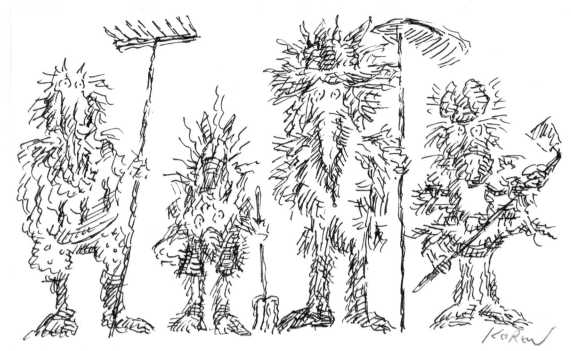

Stewards, 1998 (cat. 74)

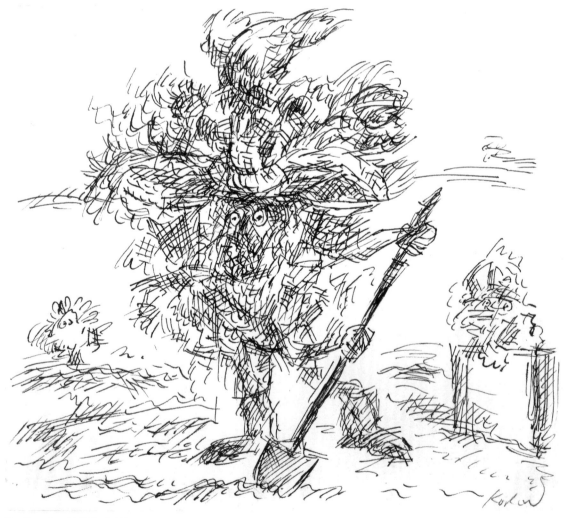

Earthworker, 1998 (cat. 73)

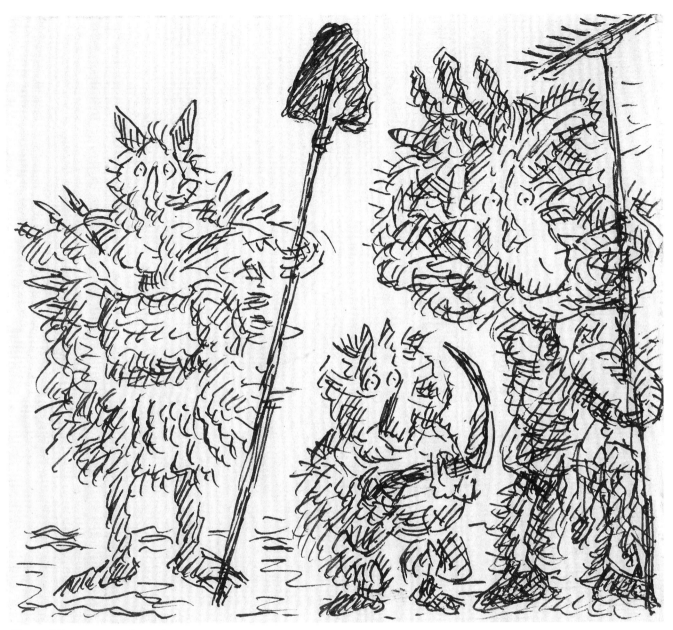

Tillers and Harvester, 1998 (cat. 75)

Preliminary sketch for "Our operations here close down today . . ." 2004 (cat. 77)

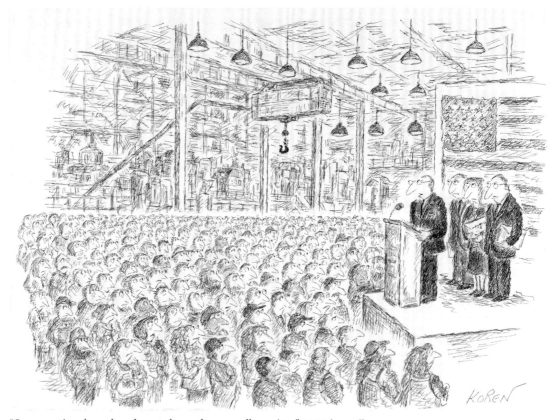

"Our operations here close down today, and you are all emeritus." 2004 (cat. 76)

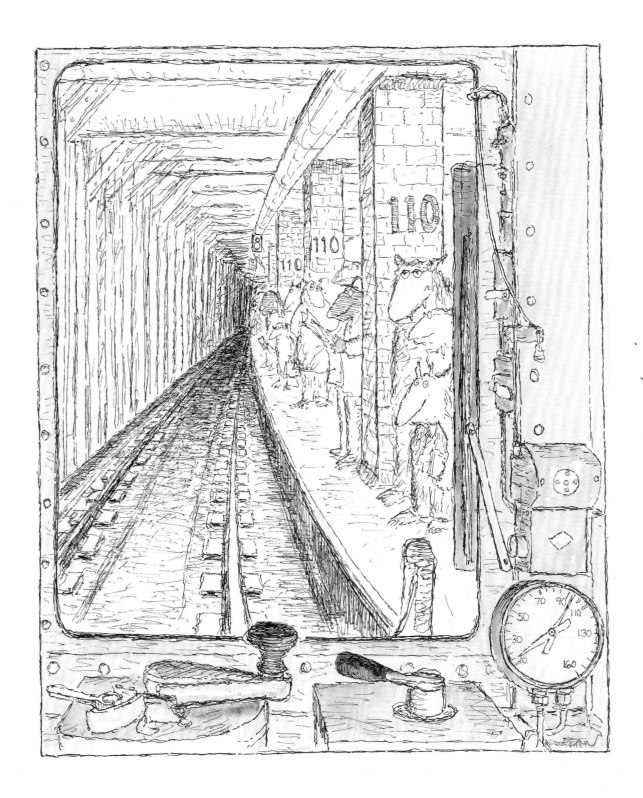

Broadway Local, 1972 (cat. 79)

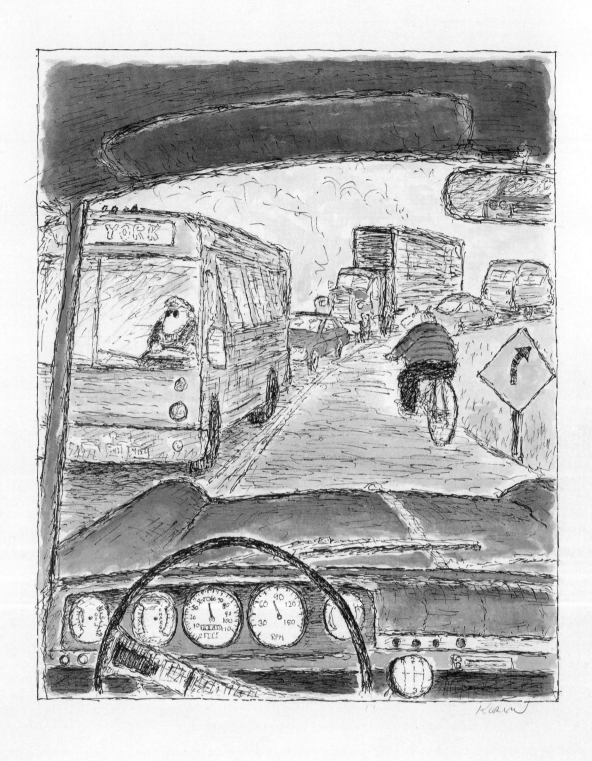

Share the Road, 1972 (cat. 78)

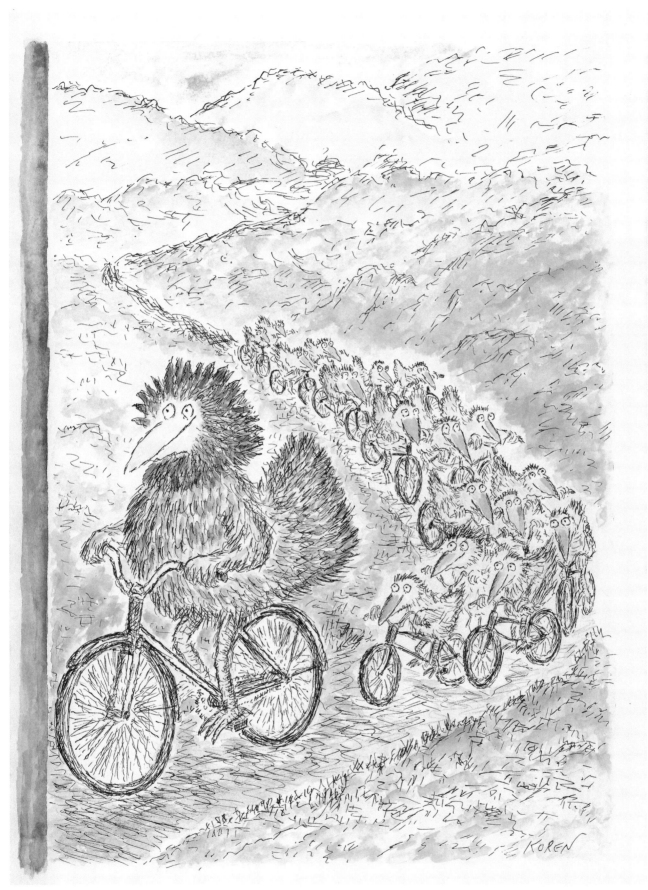

Chickens on Bikes, 1987 (cat. 80)

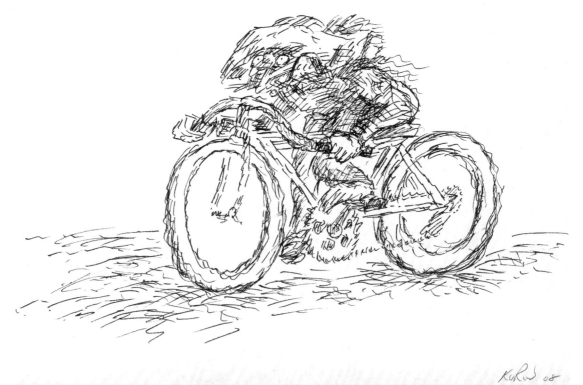

Wheeling I, 2008 (cat. 81)

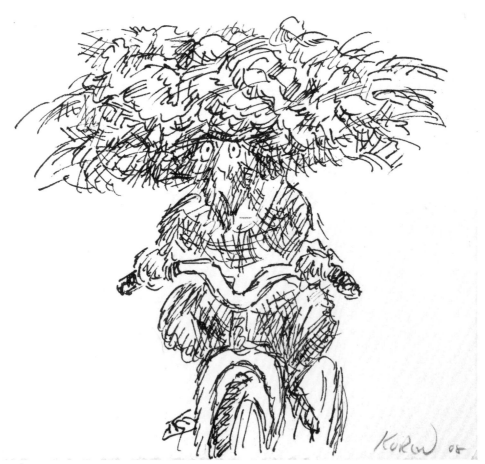

Wheeling II, 2008 (cat. 82)

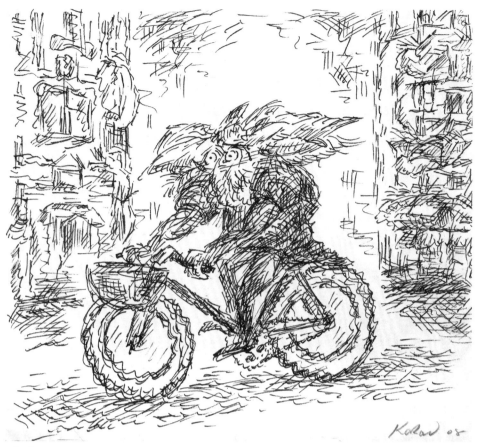

Wheeling III, 2008 (cat. 83)

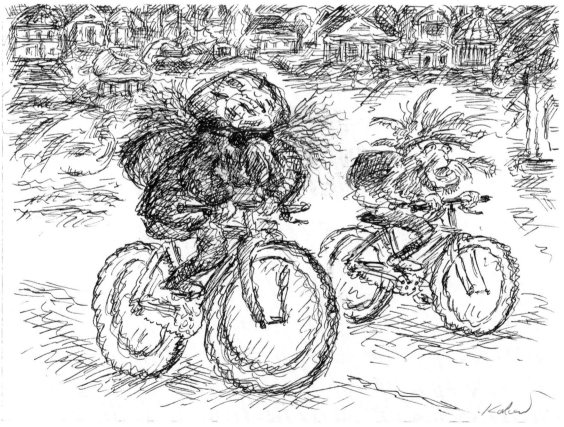

Wheeling IV, 2008 (cat. 84)

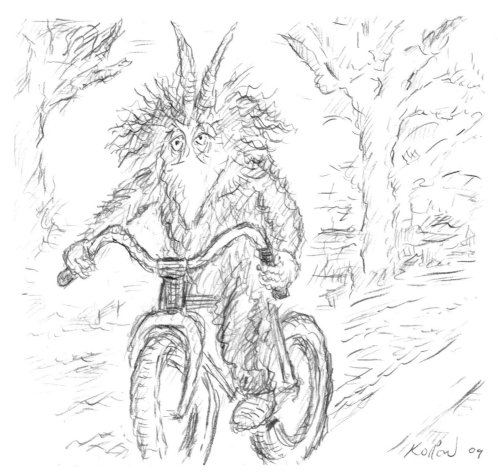

Wheeling V, 2009 (cat. 85)

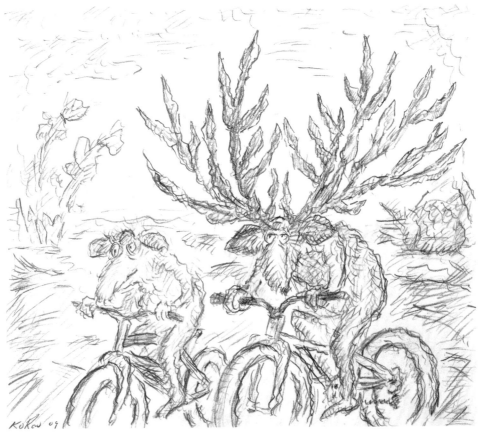

Wheeling VI, 2009 (cat. 86)

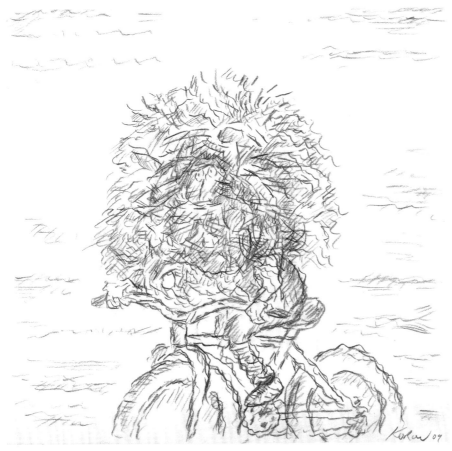

Wheeling VII, 2009 (cat. 87)

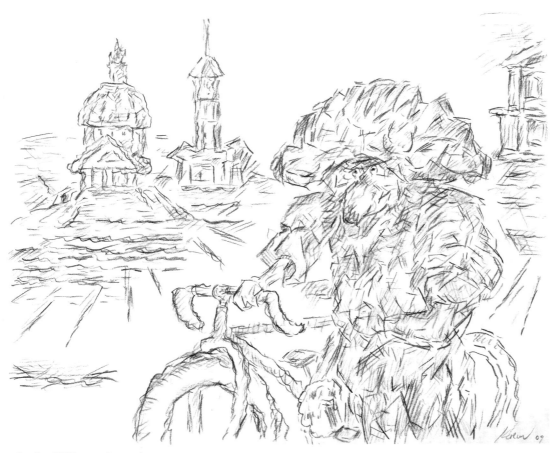

Wheeling VIII, 2009 (cat. 88)

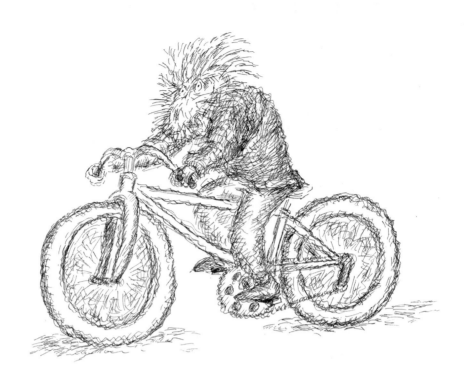

Wheeling IX, 2009 (cat. 89)

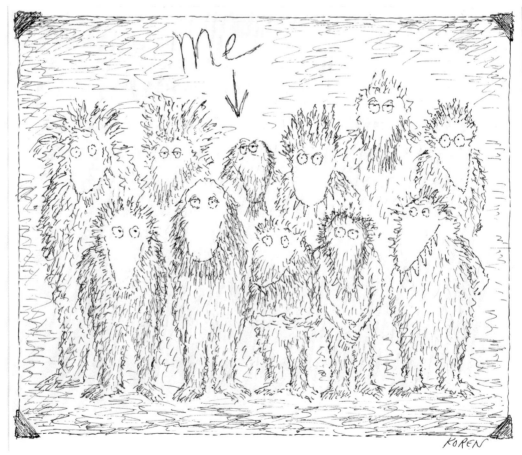

Me, 1976 (cat. 90)

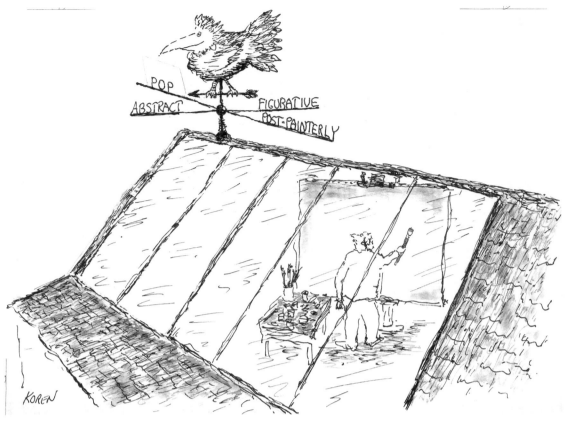

Style Weathervane, 1968 (cat. 93)

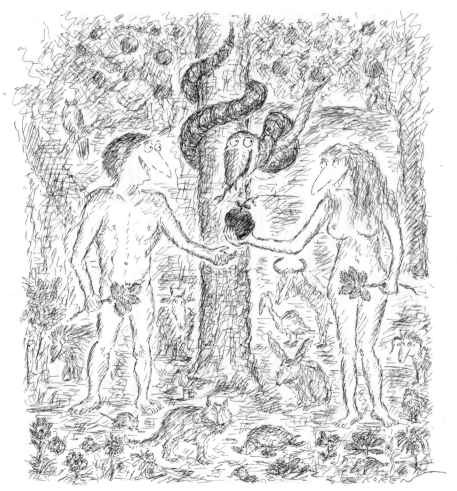

"You guys are certainly in the right place at the right time." 1991 (cat. 92)

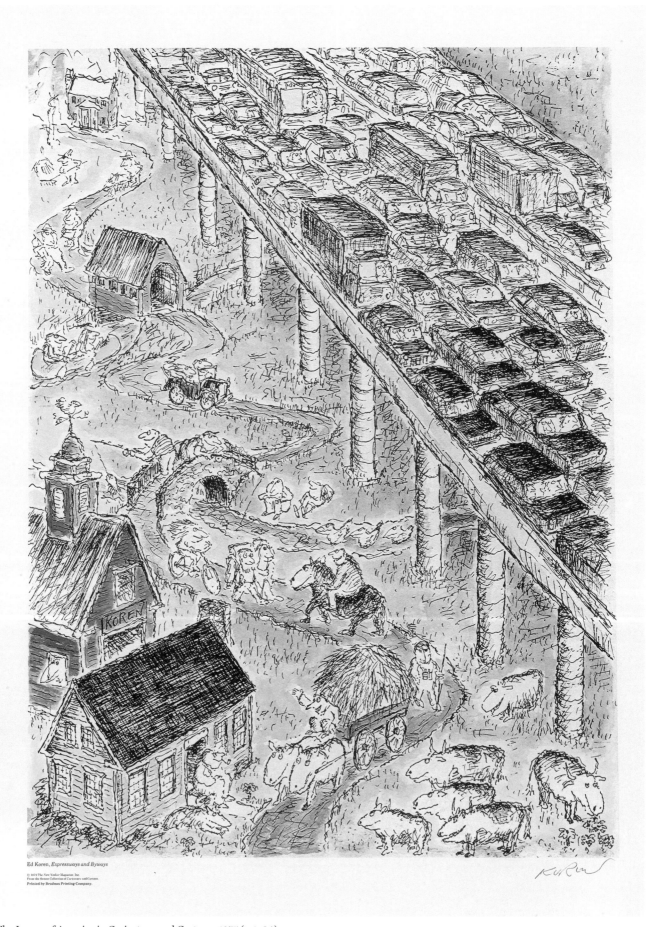

The Image of America in Caricature and Cartoon, 1975 (cat. 94)

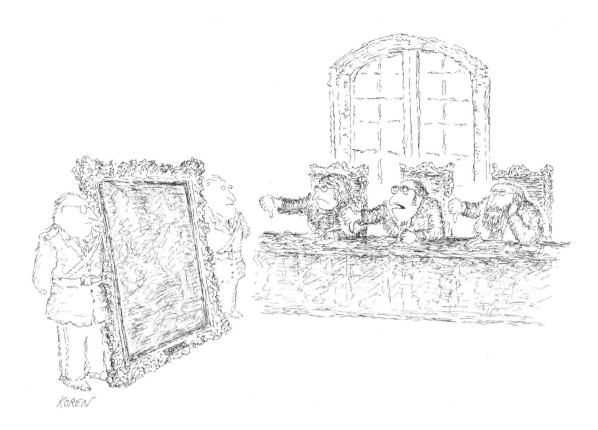

"De-access!" 1973 (cat. 96)

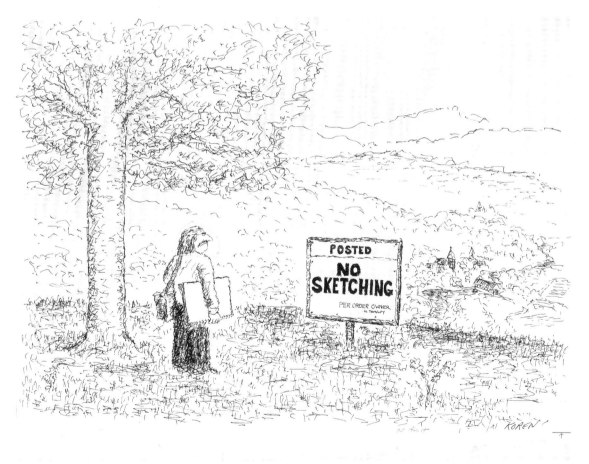

Posted – No Sketching, 1972 (cat. 95)

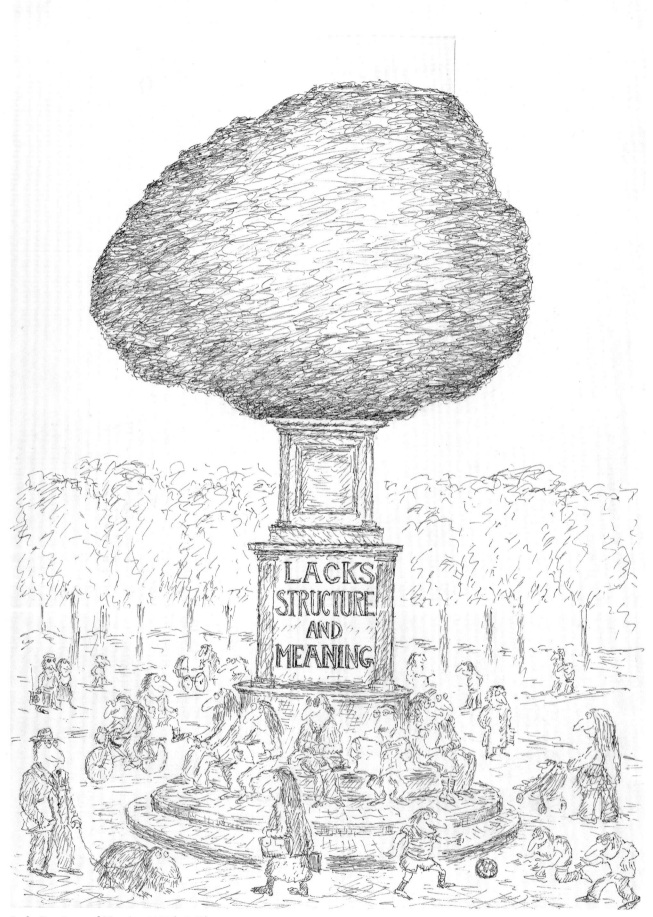

Lacks Structure and Meaning, 1980 (cat. 97)

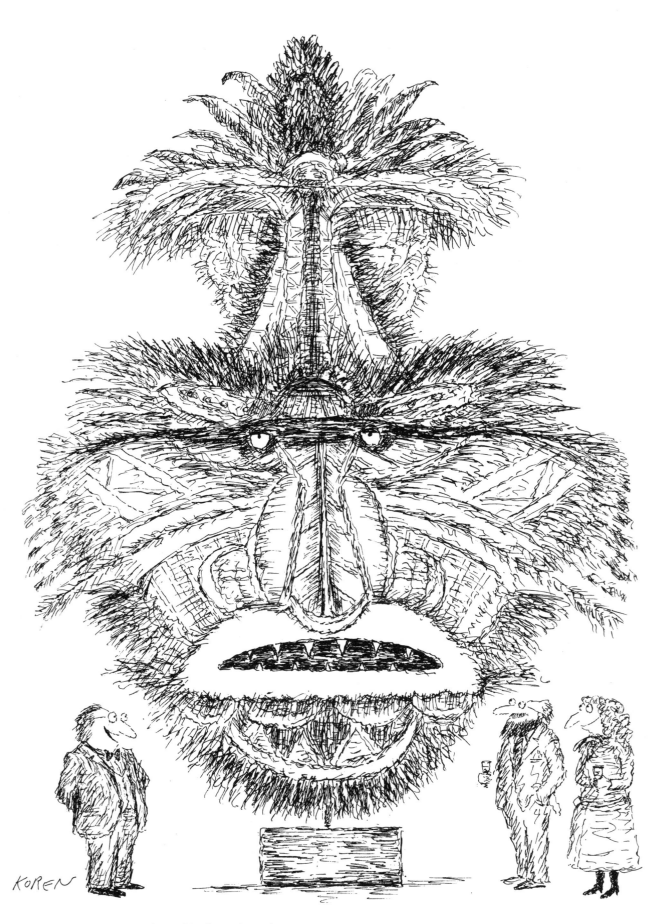

98. "Its mere possession is immensely satisfying." 1984 (cat. 98)

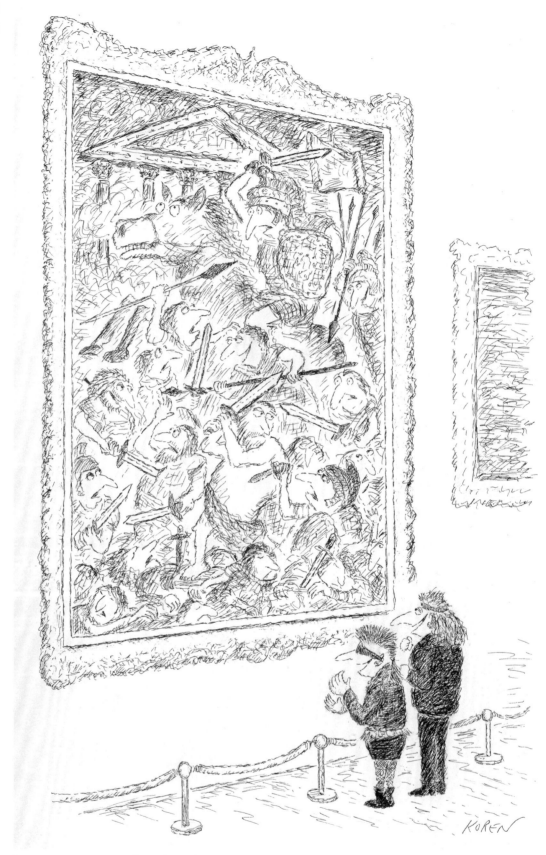

"AAAAALLLLL RIIIGHT!" 1985 (cat. 99)

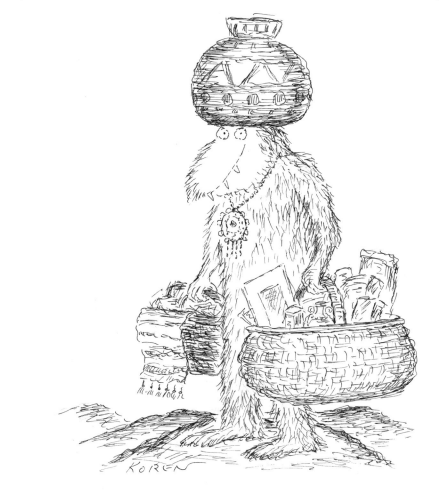

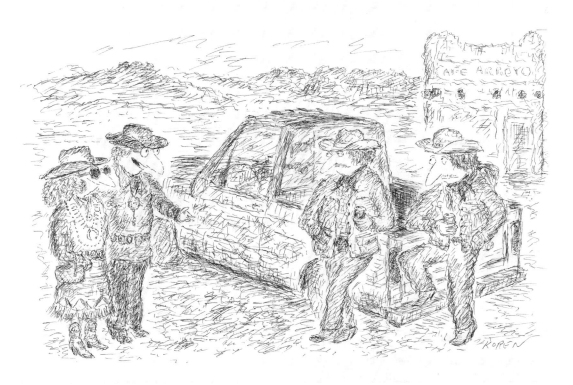

"We collect cowboy-and-Indian paraphernalia. How much would you take for your pickup?" 1991 (cat. 101)

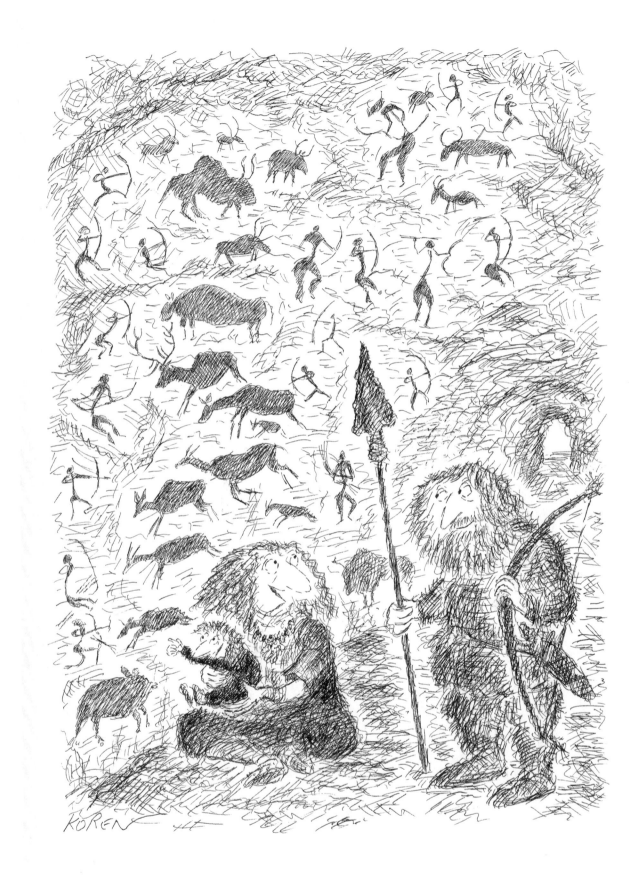

"We're working on reading readiness." 2000 (cat. 102)

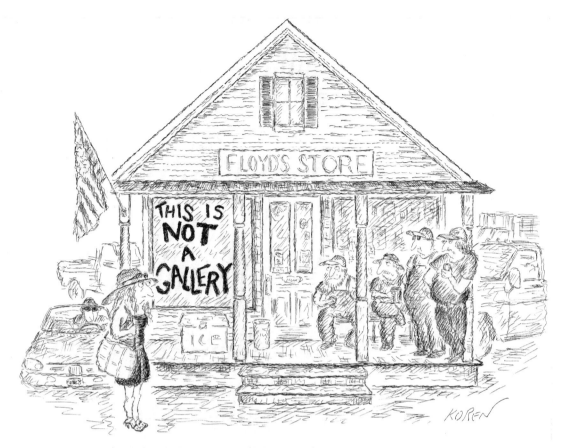

This Is Not a Gallery, 2002 (cat. 103)

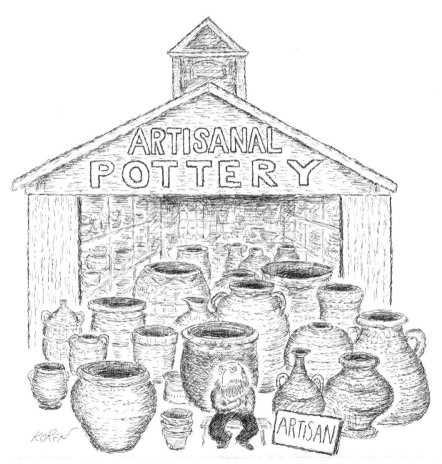

Artisanal Pottery, 2006 (cat. 106)

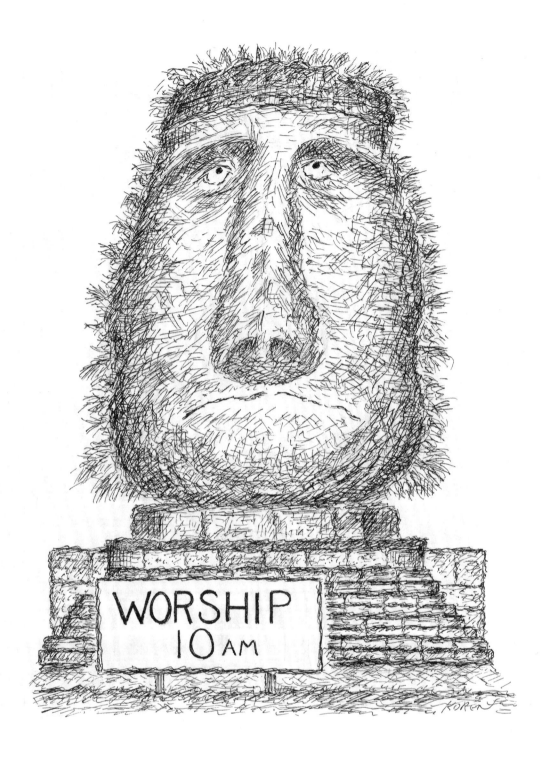

Worship 10 a.m., 2003 (cat. 104)

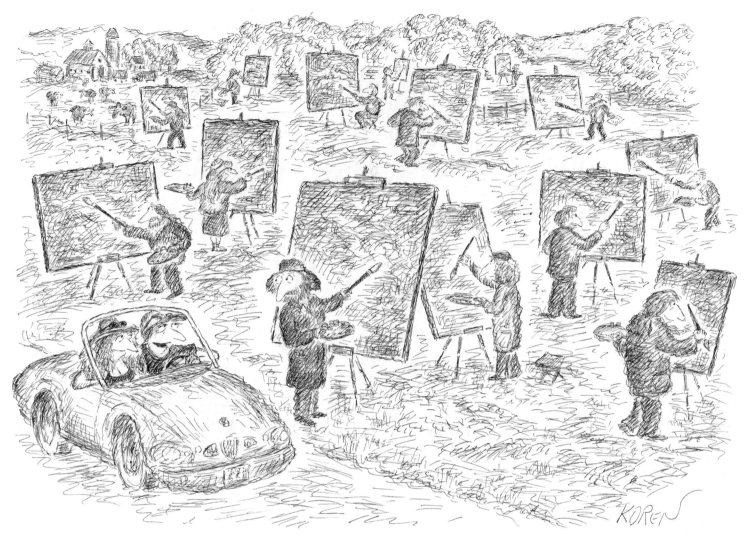

"Any impressionists in this crowd?" 2004 (cat. 105)

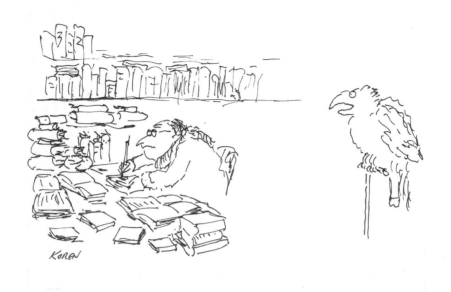

"Concept . . . generalization . . . articulaton . . . conclusion!" 1967 (cat. 107)

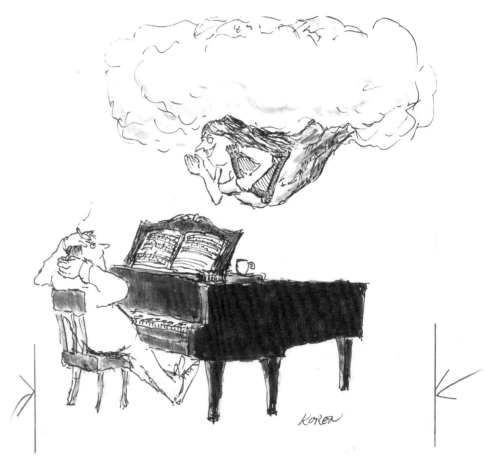

"Try 'Dum-de-<u>dum</u>-dum, dum-de-<u>dum</u>." 1965 (cat. 110)

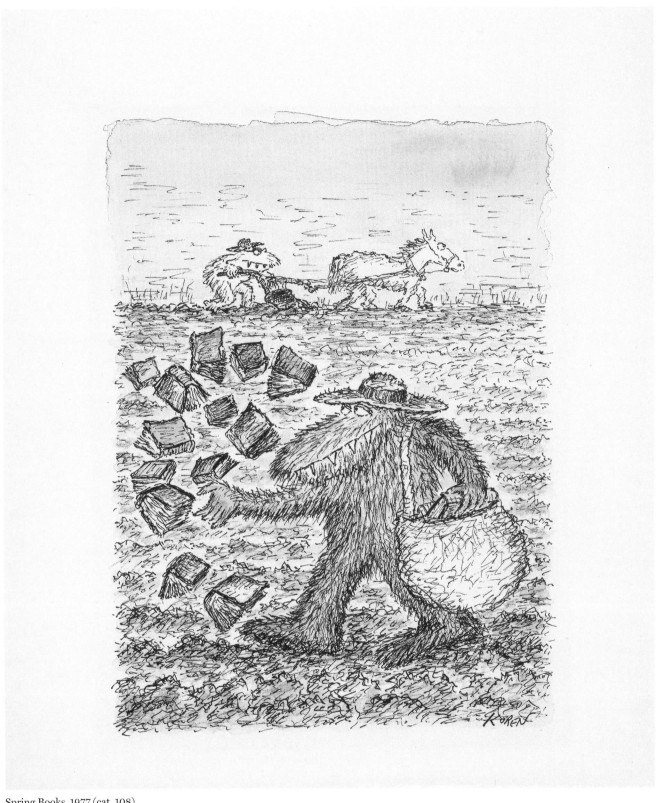

Spring Books, 1977 (cat. 108)

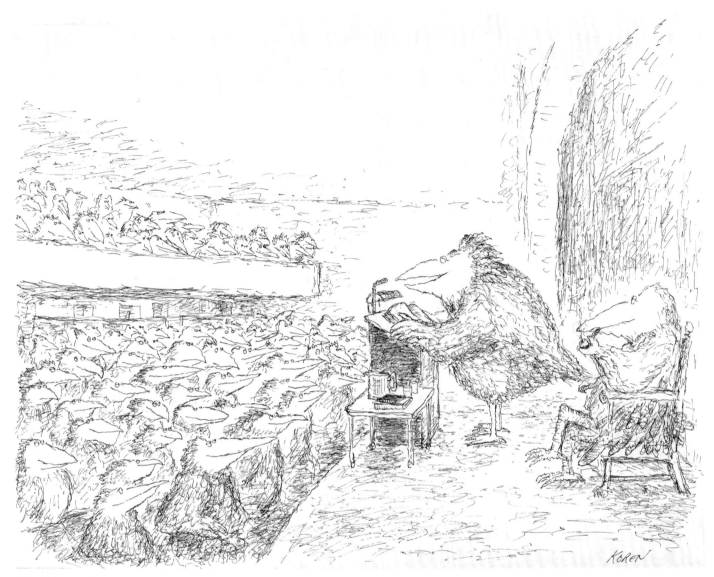

"The night woods
Listen attentively
To the owl's
 discourse,
While at dawn
The grosbeak
Elaborates the lightening sky
With musical significance."

1979 (cat. 109)

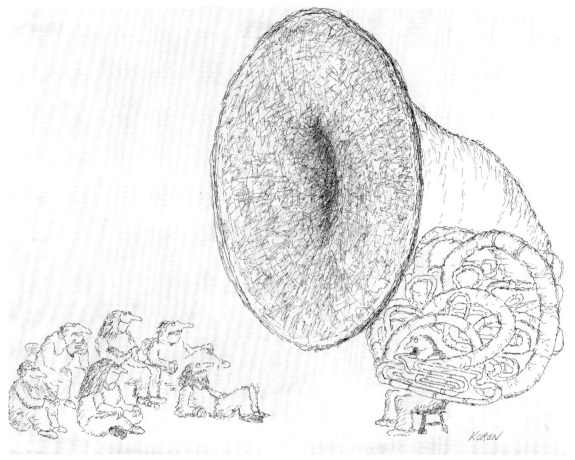

Caught in Rapture, 1975 (cat. 111)

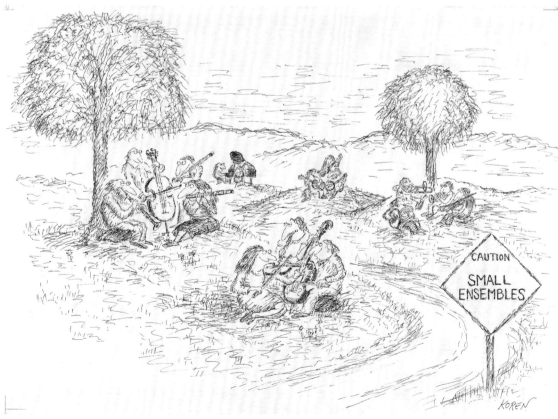

Caution – Small Ensembles, 1980 (cat. 112)

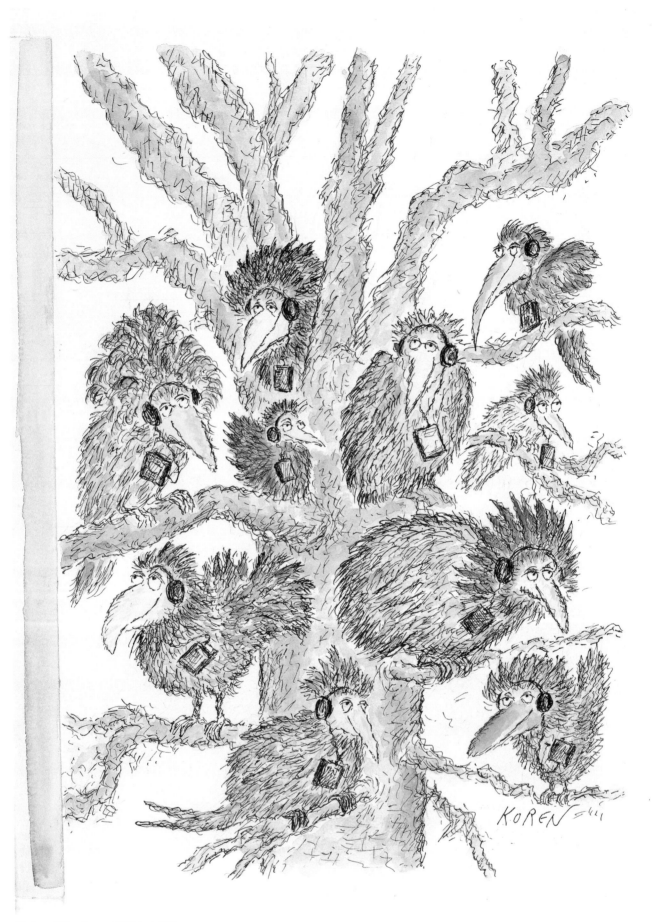

Birds and Earphones, 1988 (cat. 114)

88

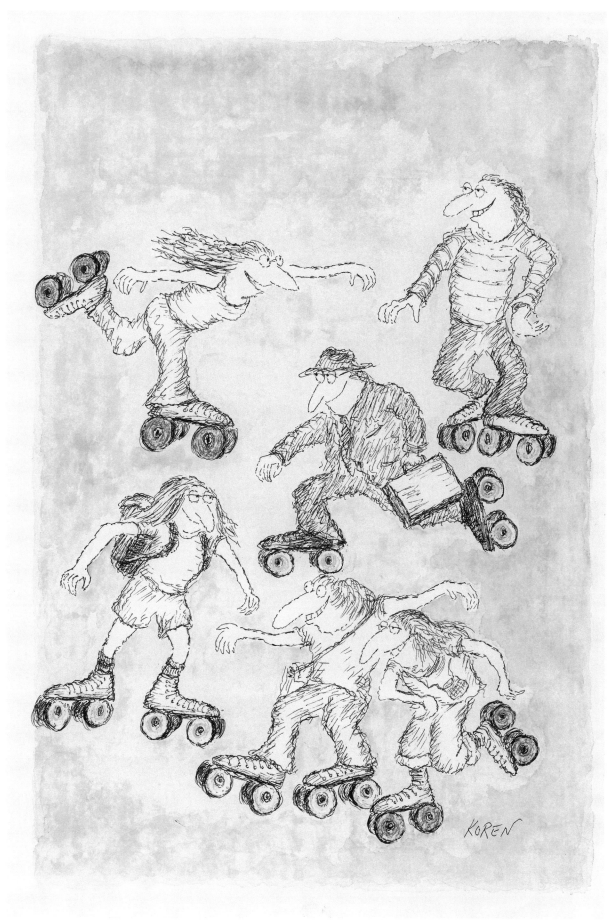

Roller Skaters, 1979 (cat. 117)

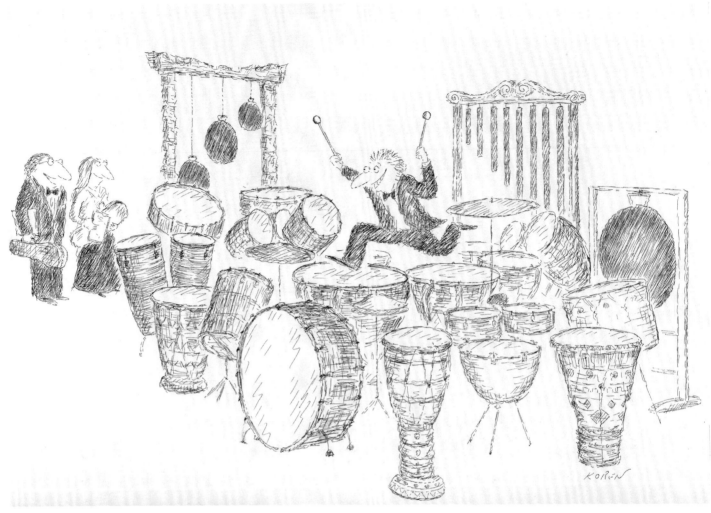

"Sam is a percussionist's percussionist." 1985 (cat. 113)

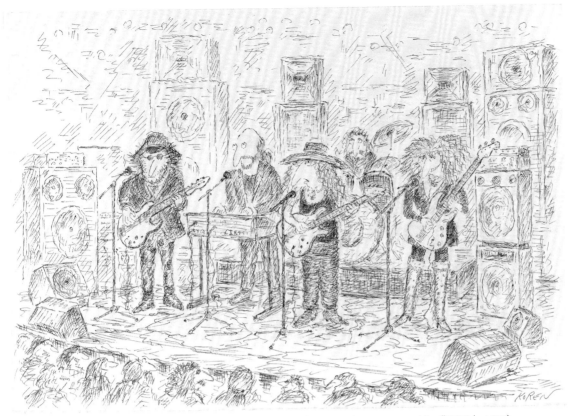

"This song is dedicated to our parents, and is in the form of a plea for more adequate supervision." 1990 (cat. 115)

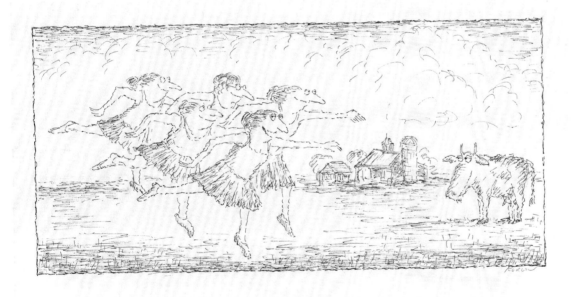

Mary Lou Barton and the Dry River Municipal Ballet, 1978 (cat. 116)

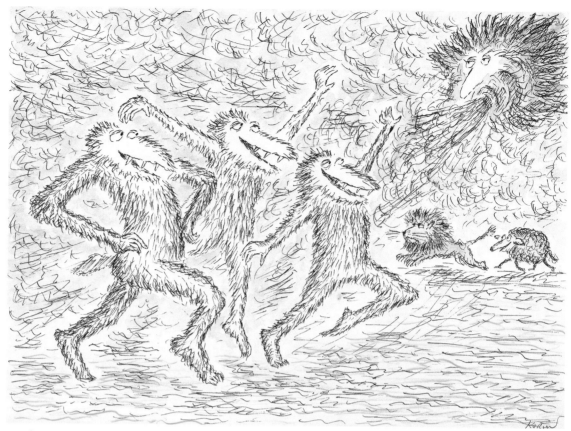

March, Joyce Theater Calendar, 1989 (cat. 118)

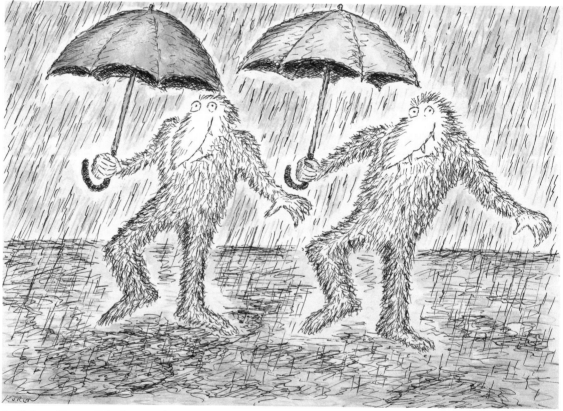

April, Joyce Theater Calendar, 1989 (cat. 119)

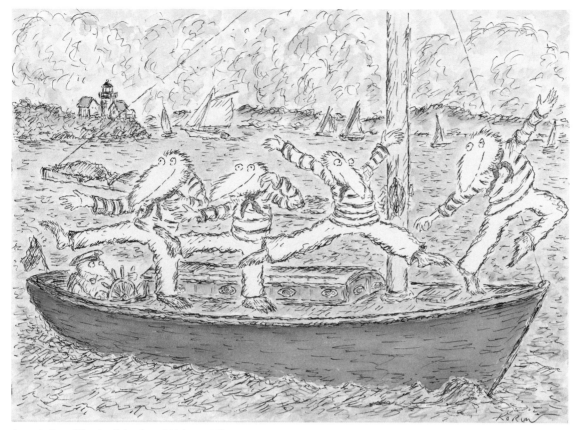

August, Joyce Theater Calendar, 1989 (cat. 120)

Catalogue of the exhibition

All works are from the collection of the artist unless otherwise indicated.
Dimensions are in inches, height before width.

PREMONITIONS

1 · She Played Well, I Say, Thinking of You, 1964

 Etching on BFK Rives paper
 17¾ x 18 (plate), 22¼ x 19⅞ (sheet)

2 · Through My Windshield, 1965

 Etching on Arches paper
 21¾ x 27½ (plate), 27¼ x 33 (sheet)

3 · Historic Landmark, 1967

 Etching on BFK Rives paper
 14 x 16⅞ (plate), 20 x 25¾ (sheet)

DENTALSCAPES

4 · Shall We Dance? 1968

 Pen and India ink on Arches paper
 22¼ x 29⅞

5 · Homage to Dr. French, 1969–70

 Pen and India ink on Arches paper
 22⅜ x 30⅛

6 · Too Many Teeth, 1970

 Pen and India ink on Arches paper
 22¼ x 30⅛

7 · "I detect a little laxity in your flossing." 1991

 Pen and India ink on BFK Rives paper
 20⅞ x 25¼
 The New Yorker, December 9, 1991

8 · Hôtel Moderne, 1974
> Pen and India ink on Arches paper
> 22½ x 30⅛

9 · Nouvel Hôtel Américan, 1974
> Pen and India ink on BFK Rives paper
> 20¾ x 30

10 · Hôtel de la Diversité, 1974
> Pen and India ink on Arches paper
> 22½ x 30⅛

11 · Hôtel d'Amour, 1974
> Pen and India ink on Arches paper
> 15⅛ x 15¼

CREATURES

12 · The Sordid Perils, 1979
> Pen and India ink on buff BFK Rives paper
> 14⅞ x 20⅞

13 · Cast a Cold Eye, 1979
> Pen and India ink with red pencil on gray Fabriano paper
> 20½ x 26½

14 · More Lives Than One, 1979
> Pen and India ink with red pencil on buff Fabriano paper
> 20⅛ x 26½

15 · Brookfield Bathers I, 1979
> Pen and India ink with colored pencil on buff Fabriano paper
> 20⅛ x 26½

16 · Brookfield Bathers II, 1979
> Pen and India ink with colored pencil on buff Fabriano paper
> 20½ x 26½

17 · Brookfield Bathers IV, 1979
> Pen and India ink with red pencil on gray Fabriano paper
> 20 x 26¼

18 · Interested? Let's Make A Deal. 1981
> Pen and India ink on Arches paper
> 29⅝ x 20¾
> *The New Yorker*, June 1, 1981

ARCHITECTURAL FANTASY

19 · Castle with Garbage Cans, 1971

> Pen and India ink on bond paper
> 24⅛ x 18⅞
> *The New Yorker,* February 21, 1971

20 · "What did they give you—National Landmark or Historical Monument?" 1971

> Pen and India ink on bond paper
> 18⅞ x 24
> *The New Yorker,* June 12, 1971

21 · Pantheon Books: Cover of 1981 Spring Catalogue, 1981

> Pen and India ink on Arches paper
> 14¾ x 20⅝

22 · "Our goal is to modernize it but retain the historical flavor." 1987

> Pen and India ink on BFK Rives paper
> 22⅛ x 29
> *The New Yorker,* April 20, 1987

23 · "And this one is listed in the National Register of Historic Places." 1990

> Pen and India ink on BFK Rives paper
> 21 x 29⅝
> *The New Yorker,* May 21, 1990

24· "Great for worship then! Great for retail now!" 1999

> Pen and India ink on BFK Rives paper
> 21 x 22½
> *The New Yorker,* September 20, 1999

25 · Honorarium, 2004

> Pen and India ink on BFK Rives paper
> 19½ x 25½

26 · The Favors of Fortune, 2004

> Pen and India ink on BFK Rives paper
> 23 x 26⅝

27 · Nothing Is Lost, 2004

> Pen and India ink on BFK Rives paper
> 22 x 30¼

28 · First Love I, 1982

> Red pencil on BFK Rives paper
> 13¼ x 5½

29 · First Love II, 1982

> Blue pencil on BFK Rives paper
> 12¾ x 6¼

30 · First Love III, 1982

> Blue pencil on BFK Rives paper
> 13⅛ x 7¾

31 · Comici I, 1982

> Blue-gray and red pencil on BFK Rives paper
> 10½ x 4⅛

32 · Comici II, 1982

> Black pencil on BFK Rives paper
> 10 x 4¾

33 · Comici III, 1982

> Brown pencil on BFK Rives paper
> 10 x 3¾

34 · Comici IV, 1982

> Green pencil on BFK Rives paper
> 13⅛ x 6¾

35 · Comici V, 1982

> Blue pencil on BFK Rives paper
> 13⅛ x 4¼

36 · Comici VI, 1982

> Green pencil on BFK Rives paper
> 13 x 4¼

37 · Comici VII, 1982

> Green pencil on BFK Rives paper
> 10 x 5⅛

38 · Comici VIII, 1982

> Black pencil on BFK Rives paper
> 10 x 6⅝

39 · Comici IX, 1982

> Brown pencil on BFK Rives paper
> 10 x 6⅝

40 · Comici X, 1982

> Brown, gray, and black pencil on BFK Rives paper
> 13⅛ x 6

41 · Comici XI, 1982

> Green pencil on BFK Rives paper
> 13¼ x 7¾

42 · Comici XII, 1983

> Blue and green pencil on Arches paper
> 8½ x 16

43 · Just Typical, 1989–90

> Colored pencil on gray Fabriano paper
> 20 x 26⅜

NATURAL HISTORY

44 · "We deal with it by talking about it." 1975

> Pen and India ink on bond paper
> 18⅞ x 24
> *The New Yorker*, January 6, 1975

45 · Noah's Ark, 1975

> Pen and India ink on bond paper
> 18½ x 24
> *The New Yorker*, November 24, 1975

46 · "The reason you all are becoming extinct is that you can't take a joke." 1977

> Pen and India ink on bond paper
> 18¾ x 24
> *The New Yorker*, April 18, 1977

47 · "Isn't it astonishing that no two of us are exactly alike?" 1982

> Pen and India ink on Arches paper
> 19¾ x 25⅝
> *The New Yorker*, June 10, 1982

48 · "It looks like the ornithosuchians are attempting a comeback." 1984

> Pen and India ink on BFK Rives paper
> 20⅞ x 28⅜
> *The New Yorker*, February 27, 1984

49 · Grazing Gaze, 1985

> Pen and India ink on Fabriano paper
> 26⅜ x 40¼

50 · Blood Sound (after Paul Zweig), 1985

> Pen and India ink on Fabriano paper
> 26¼ x 40½

51 · Sleepless Nights (after Paul Zweig), 1985–86
 Pen and India ink on Fabriano paper
 26¼ x 40¼

52 · Seven Friends, 1987
 Pen and India ink on gray BFK Rives paper
 30 x 42¼

53 · "This is a great place to raise children." 1990
 Pen and India ink on BFK Rives paper
 18⅜ x 29⅝
 The New Yorker, October 15, 1990

54 · "The message here is 'Hydrate, hydrate, hydrate!'" 2007
 Pen and India ink on BFK Rives paper
 21 x 25⅝
 The New Yorker, April 20, 2009

NATURE AND MAN

55 · Landscape of Metaphors, 1979
 Pen and India ink on Arches paper
 26 x 21
 The New Yorker, October 8, 1979

56 · "And on my right is Joe Nast, representing an opposing viewpoint." 1982
 Pen and India ink on Arches paper
 22¼ x 28⅝
 The New Yorker, August 8, 1983

57 · "The weather looks a little iffy." 1986
 Pen and India ink on Arches paper
 22⅝ x 29½
 The New Yorker, August 31, 1987

58 · "Honey, are you thinking about the office?" 1989
 Pen and ink on BFK Rives paper
 19½ x 27⅛
 The New Yorker, June 5, 1989

59 · 24-Hour Banking, 1990
 Pen and India ink with watercolor and colored pencil on BFK Rives paper
 24¾ x 19⅛
 The New Yorker (cover), May 7, 1990

60 · Final Clearance Entire Stock of Kangaroos, 1991
 Pen and India ink on BFK Rives paper
 18¾ x 27
 The New Yorker, April 29, 1991

61 · The Most Unkindest Cut, 1991

Pen and India ink with watercolor and colored pencil on BFK Rives paper

26⅝ x 20⅞

The New Yorker, July 19, 1993

62 · "You hate to shop—I hate to hunt." 1992

Pen and India ink on BFK Rives paper

22¼ x 29

The New Yorker, September 28, 1992

63 · "Your father and I want to explain why we've decided to live apart." 1995

Pen and India ink on BFK Rives paper

21 x 25½

The New Yorker, February 6, 1995

HANDS ON

64 · "Your work must be very satisfying." 1969

Pen and India ink, with corrections in white acrylic paint, on bond paper

18⅞ x 24

The New Yorker, February 21, 1970

65 · Celebrating the National Building Museum, 1981

Offset lithograph

36 x 22

66 · "I've been a great admirer of your work for years. It's a real pleasure to meet you."
"I'm happy to meet you. I'm your biggest fan." 1983

Pen and India ink on Arches paper

20¼ x 29

The New Yorker, December 6, 1982

67 · "Where's the business end of this thing?" 1983

Pen and India ink on Arches paper

30 x 22¼

The New Yorker, August 1, 1983

68 · Men Drinking Coffee, 1984

Pen and India ink on BFK Rives paper

22⅜ x 29½

The New Yorker, April 16, 1984

69 · "I'd like my daughter to know something about engines." 1989

Pen and India ink on BFK Rives paper

22½ x 28½

The New Yorker, October 22, 1990

70 · "What's it like, working with your hands?" 1990

Pen and India ink on BFK Rives paper

21 x 27½

The New Yorker, December 17, 1990

71 · "We can't tell if it's a malfunction or a dysfunction." 1991

> Pen and India ink on BFK Rives paper
> 16⅝ x 22¼
> *The New Yorker*, December 2, 1991
> Collection Carol Zicklin and the late Robert Zicklin

72 · "I've done my tour of duty on Wall Street." 1992

> Pen and India ink on BFK Rives paper
> 22⅛ x 30
> *The New Yorker*, November 2, 1992

73 · Earthworker, 1998

> Pen and India ink on BFK Rives paper
> 7¾ x 9

74 · Stewards, 1998

> Pen and India ink on BFK Rives paper
> 6 x 10⅛

75 · Tillers and Harvester, 1998

> Pen and India ink on BFK Rives paper
> 5½ x 6½

76 · "Our operations here close down today, and you are all emeritus." 2004

> Pen and India ink on BFK Rives paper
> 20¾ x 29⅜
> *The New Yorker*, March 22, 2004

77 · Preliminary sketch for "Our operations here close down today..." 2004

> Pencil on bond paper
> 6⅞ x 11

WHEELS

78 · Share the Road, 1972

> Pen and India ink with watercolor on Arches paper
> 22⅜ x 19¼
> *Behind the Wheel*, by Edward Koren (New York: Holt, Rinehart, Winston, 1972)

79 · Broadway Local, 1972

> Pen and India ink with watercolor on Arches paper
> 22¼ x 19⅛
> *Behind the Wheel*, by Edward Koren (New York: Holt, Rinehart, Winston, 1972)

80 · Chickens on Bikes, 1987

> Pen and India ink with watercolor on Arches paper
> 25 x 18⅝
> *The New Yorker* (cover), June 15, 1987

81 · Wheeling I, 2008

> Pen and India ink on BFK Rives paper
> 10½ x 15

82 · Wheeling II, 2008

> Pen and India ink on BFK Rives paper
> 6⅝ x 7⅜

83 · Wheeling III, 2008

> Pen and India ink on buff Arches paper
> 9¼ x 10½

84 · Wheeling IV, 2008

> Pen and India ink on BFK Rives paper
> 10¾ x 15

85 · Wheeling V, 2009

> Pencil on BFK Rives paper
> 9¼ x 10

86 · Wheeling VI, 2009

> Pencil on BFK Rives paper
> 9¼ x 10⅝ in

87 · Wheeling VII, 2009

> Pencil on Lennox paper
> 10⅞ x 11⅜

88 · Wheeling VIII, 2009

> Pencil on Lennox paper
> 11¾ x 15

89 · Wheeling IX, 2009

> Pen and India ink on gray BFK Rives paper
> 21¼ x 25

ARTS AND LETTERS

Generalia

90 · Me, 1976

> Pen and India ink on bond paper
> 17¼ x 21⅜
> *The New Yorker,* December 13, 1976

91 · Self-Portrait, 1991

> Pen and India ink on BFK Rives paper
> 10¼ x 14⅝
> *Modern Maturity,* October–November 1991

92 · "You guys are certainly in the right place at the right time." 1991

 Pen and India ink on BFK Rives paper

 21 x 25¼

 The New Yorker, September 16, 1991

Art

93 · Style Weathervane, 1968

 Pen and India ink on bond paper

 11½ x 14¼

 The New Yorker, June 8, 1968

 The Isabel and Bates Lowry Collection

94 · The Image of America in Caricature and Cartoon, 1975

 Offset lithograph. Poster for an exhibition at the Amon Carter Museum of Western Art,

 Fort Worth, 1975, based on a pen-and-India-ink drawing from 1972

 34½ x 24

95 · Posted—No Sketching, 1972

 Pen and India ink on bond paper

 18¾ x 24¼

 The New Yorker, July 1, 1972

 Collection Cynthia (Toni) King

96 · "De-access!" 1973

 Pen and India ink on bond paper

 18¾ x 23⅞

 The New Yorker, May 19, 1973

97 · Lacks Structure and Meaning, 1980

 Pen and India ink on Arches paper

 21 x 28¾

 The New Yorker, July 14, 1980

98 · "Its mere possession is immensely satisfying." 1984

 Pen and India ink on BFK Rives paper

 29 x 22

 The New Yorker, October 22, 1984

 Collection Lee Lorenz

99 · "AAAAALLLLL RIIIGHT!" 1985

 Pen and India ink on buff BFK Rives paper

 28½ x 19¼

 The New Yorker, January 13, 1986

100 · Artisanal Crafts, 1986

 Pen and India ink on paper

 13⅜ x 10⅝

101 · "We collect cowboy-and-Indian paraphernalia. How much would you take
for your pickup?" 1991

Pen and India ink on BFK Rives paper

21⅞ x 29¾

The New Yorker, November 25, 1991

102 · "We're working on reading readiness." 2000

Pen and India ink on BFK Rives paper

26¼ x 19⅜

The New Yorker, June 19, 2000

103 · This Is Not a Gallery, 2002

Pen and India ink on BFK Rives paper

21 x 27¾

The New Yorker, July 22, 2002

104 · Worship 10 a.m., 2003

Pen and India ink on BFK Rives paper

20⅜ x 15½

The New Yorker, March 8, 2004

105 · "Any impressionists in this crowd?" 2004

Pen and India ink on BFK Rives paper

21 x 29⅝

The New Yorker, July 24, 2004

106 · Artisanal Pottery, 2006

Pen and India ink on BFK Rives paper

21⅛ x 21

The New Yorker, September 18, 2006

Letters

107 · "Concept . . . generalization . . . articulation . . . conclusion!" 1967

Pen and India ink on bond paper

11½ x 14⅜

The New Yorker, April 1, 1967

108 · Spring Books, 1977

Pen and India ink with watercolor and colored pencil on Arches paper

17⅛ x 14¾

Publishers Weekly (cover), January 23, 1978

109 · "The night woods / Listen attentively / To the owl's / discourse, / While at dawn / The grosbeak / Elaborates the lightening sky / With musical significance." 1979

Pen and India ink with wash and white pigment on bond paper

18¾ x 24

The New Yorker, June 11, 1979

Music

110 · "Try 'Dum-de-dum-dum, dum-de-dum.'" 1965

Pen and India ink on bond paper

9 x 12

The New Yorker, December 18, 1965

111 · Caught in Rapture, 1975

> Pen and India ink on bond paper
> 18¾ x 24⅛
> *The New Yorker,* June 9, 1975

112 · Caution—Small Ensembles, 1980

> Pen and India ink on Arches paper
> 21 x 29⅝
> *The New Yorker,* September 1, 1980

113 · "Sam is a percussionists' percussionist." 1985

> Pen and India ink on BFK Rives paper
> 24¼ x 19⅛
> *The New Yorker,* April 14, 1986

114 · Birds and Earphones, 1988

> Pen and India ink with watercolor and colored pencil on BFK Rives paper
> 24¼ x 19⅛
> *The New Yorker* (cover), June 20, 1988

115 · "This song is dedicated to our parents, and is in the form of a plea for more adequate supervision." 1990

> Pen and India ink on BFK Rives paper
> 21 x 29¾
> *The New Yorker,* October 28, 1991

Dance

116 · Mary Lou Barton and the Dry River Municipal Ballet, 1978

> Pen and ink on Arches paper
> 14¾ x 20¾
> Illustration for "The Enquiring Demographer," *The New Yorker,*
> December 11, 1978

117 · Roller Skaters, 1979

> Pen and India ink with watercolor and colored pencil on BFK Rives paper
> 28¾ x 20¾
> *The New Yorker* (cover), August 20, 1979
> Collection Eugenia Robbins

118 · March, Joyce Theater Calendar, 1989

> Pen and India ink with watercolor and colored pencil on BFK Rives paper
> 14⅞ x 20¾ in

119 · April, Joyce Theater Calendar, 1989

> Pen and India ink with watercolor and colored pencil on BFK Rives paper
> 14¾ x 21

120 · August, Joyce Theater Calendar, 1989

> Pen and India ink with watercolor and colored pencil on BFK Rives paper
> 15 x 20¾

Biography

Born in New York City in 1935, Edward Koren attended the Horace Mann School and then Columbia College, where he received a BA in 1957. At Columbia he drew for the college's humor magazine, *Jester of Columbia*, of which he became editor in chief.

Following his graduation from Columbia, Koren spent the next two years, from 1957 to 1959, in Paris studying printmaking as a member of S. W. Hayter's Atelier 17. In 1958 he was awarded a Woolley Fellowship by the Fondation des États-Unis, Paris. Returning to the United States, he entered the graduate program of Pratt Institute, receiving an MFA degree in painting and printmaking in 1964. He then joined the faculty of Brown University, where he taught until 1977.

Koren published the first of his cartoons with *The New Yorker* in 1962 and has continued to draw for the magazine ever since. He has published ten of his own books and has illustrated more than twenty others. His own fascination with wheels and things that go inspired his second book, *Behind the Wheel* (1972), which was cited by the *New York Times* as one of the ten best children's books of the year; in addition, it received international honors, including the Golden Plaque at the Biennale of Illustration in Bratislava, Czechoslovakia. For his contribution to the art of the cartoon, in 1973 he was awarded the Prix d'Honneur of the Société Protectrice de l'Humour, Avignon, France.

A recipient of a John Simon Guggenheim Fellowship in 1970–1971, Koren was Distinguished Visitor at the American Academy in Berlin in 2003. He was awarded the degree of Honorary Doctor of Humane Letters by Union College in 1984. The state of Vermont, where has lived for many years, honored him in 2007 with the Governor's Award for Excellence in the Arts.

Books

BOOKS BY EDWARD KOREN

Don't Talk to Strange Bears
> New York: Windmill Books / Simon & Schuster, 1969

Behind the Wheel
> New York: Holt, Rinehart & Winston, 1972

Do You Want to Talk About It?
> New York: Pantheon Books, 1976
> *Möchtest du darüber sprechen?* Munich:
> Schirmer / Mosel, 1980

Are You Happy? And Other Questions Lovers Ask
> New York: Pantheon Books, 1978
> *Tu ne m'aimes?* Paris: Albin Michel, 1979
> *Bist du glücklich?* Munich: Schirmer / Mosel, 1979
> *Ben Je Gelukkig?* Amsterdam: Uitgeverij Bert Bakker, 1981

"Well, there's your problem"
> New York: Pantheon Books, 1980
> *Na, da haven wir ja Ihr Problem!* Munich:
> Schirmer / Mosel, 1981

The Penguin Edward Koren
> New York: Penguin Books, 1982

Caution: Small Ensembles
> New York: Pantheon Books, 1983

What About Me? Preface by Calvin Trillin
> New York: Pantheon Books, 1989

Quality Time: Parenting, Progeny, and Pets
> New York: Villard Books, 1995

The Hard Work of Simple Living: A Somewhat Blank Book for the Sustainable Hedonist
> New York: Chelsea Green Publishing, 1998

Very Hairy Harry
> New York: Joanna Cotler Books / Harper Collins, 2003

BOOKS ILLUSTRATED BY EDWARD KOREN

"No More Milk," by Matt Robinson, in *Gordon of Sesame Street Story Book*
> New York: Random House, 1971

Cooking for Crowds, by Merry White
> New York: Basic Books, 1974

The People, Maybe, by Karl Lamb
> Boston: Duxbury Press, 1974

Noodles Galore, by Merry White
> New York: Basic Books, 1976

Dragons Hate to be Discrete, by Winifred Rosen
> New York: Alfred A. Knopf, 1978

How to Eat Like a Child, and Other Lessons in Not Being a Grown-Up, by Delia Ephron
> New York: Viking Press, 1978

Teenage Romance: Or, How to Die of Embarrassment, by Delia Ephron
> New York: Viking Press, 1981

Frog Prince: A Play, by David Mamet
> New York: Vincent Fitzgerald & Co., 1984

Plane Crazy: A Celebration of Flying, by Burton Bernstein
> New York: Ticknor & Fields, 1985

A Dog's Life, by Peter Mayle
> New York: Alfred A. Knopf, 1995

Dear Bruno, by Alice Trillin
> New York: The New Press, 1996

Eight or Nine Wise Words about Letter-Writing, by Lewis Carroll
> Delray Beach: Levenger Books, 1999

Feeding the Mind, by Lewis Carroll
> Delray Beach: Levenger Books, 1999

Pet Peeves, or Whatever Happened to Dr. Rawff, by George Plimpton
> New York: Atlantic Monthly Press, 2000

The New Legal Sea Foods Cookbook, by Roger Berkowitz and Jane Doerfer
> New York: Broadway Books, 2003

Traveling While Married, by Mary-Lou Weisman
> Chapel Hill: Algonquin Books, 2003

All Together Now: Neighbors Helping Neighbors Create a Resilient New York City *Books*
 Woodstock: Empowerment Institute, 2004

Thelonius Monster's Sky-High Fly Pie, by Judy Sierra
 New York: Knopf / Random House, 2006

The Nation Guide to The Nation, by Richard Lingeman and the editors of *The Nation*
 New York: Vintage Books / Random House, 2008

Oops, poems by Alan Katz
 New York: Margaret K. McElderry Books / Simon & Schuster, 2008

How to Clean Your Room in 10 Easy Steps, by Jennifer Larue Huget
 New York: Schwartz and Wade / Random House, 2010

Printed on Mohawk paper
by Thames Printing Company.
Set in Miller types &
designed by Jerry Kelly.